Fables of La Fontaine

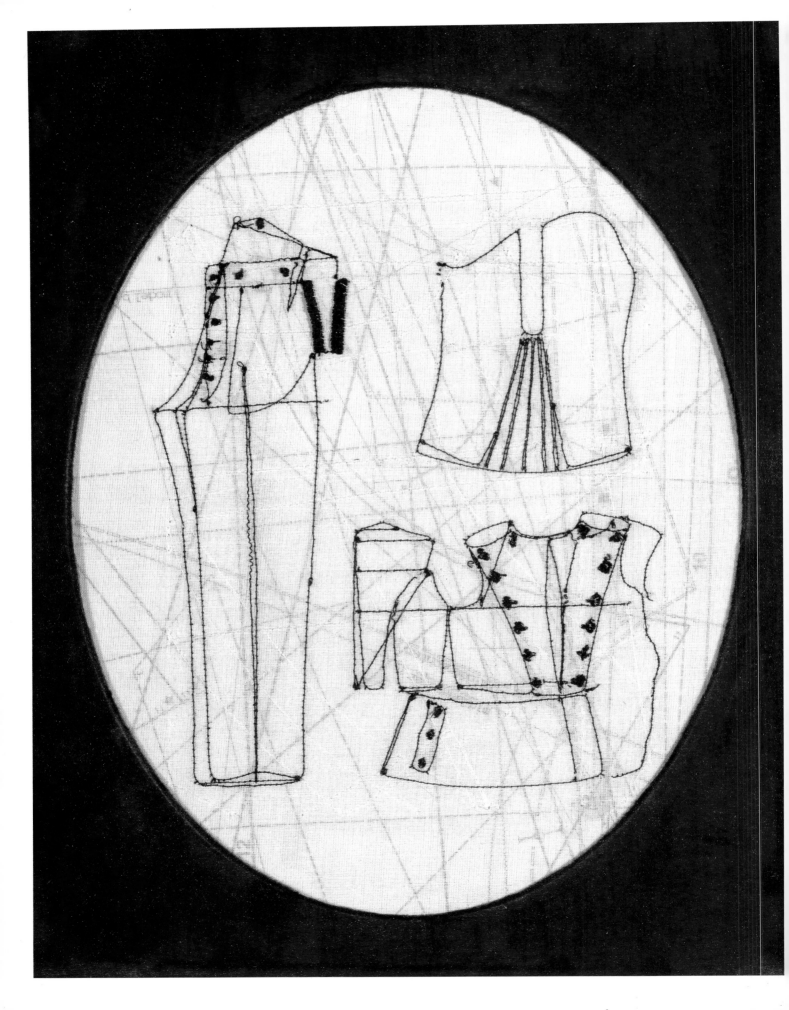

Fables of La Fontaine

COMPILED & EDITED BY

KOREN CHRISTOFIDES

Introduction by Constantine Christofides

TRANSLATIONS BY

Constantine Christofides & Christopher Carsten

UNIVERSITY OF WASHINGTON PRESS *Seattle & London*

in association with

MARYLAND INSTITUTE COLLEGE OF ART *Baltimore*

INSTITUTE FOR AMERICAN UNIVERSITIES *Aix-en-Provence*

Printed in China

12 11 10 09 08 07 06 05 5 4 3 2 1

University of Washington Press

P.O. Box 50096, Seattle, WA 98145 U.S.A.

www.washington.edu/uwpress

Library of Congress Cataloging-in-Publication Data

La Fontaine, Jean de, 1621–1695.

[Fables. English. Selections]

Fables of La Fontaine / compiled and edited by Koren Christofides ; introduction by Constantine Christofides ; translations by Constantine Christofides and Christopher Carsten.—1st ed.

p. cm.

ISBN 0-295-98599-2 (pbk. : alk. paper)

ISBN 0-295-98614-X (cl. : alk. paper)

1. La Fontaine, Jean de, 1621–1695. Fables—Illustrations. 2. Fables, French—Translations into English. I. Christofides, Koren. II. Christofides, Constantine. III. Carsten, Christopher. IV. Title.

PQ1811.E3C35 2006

841'.4—dc22 2005031067

Project director:	Koren Christofides
Art photography:	William Wickett
Text and cover design:	Audrey Seretha Meyer
Cover image:	Ken Tisa
Editor:	Gretchen Van Meter

Translations by Christopher Carsten can be found on pages 4, 6, 26, 28, 34, 36, 42, 48, 54, 60, 62, 64, 66, 78, 81, 101, 104, 112; all other translations are by Constantine Christofides

Illustrations: frontispiece "The Limbs and the Stomach" (Book III, Fable 2) by Annet Couwenberg (Holland/USA). Pages viii, xii, 148, 151, and 154 are full-bleed details of selected art from the book.

The epigraph on page 1 is from *The Letters of Robert Lowell* (Farrar, Straus and Giroux, 2004).

These pages are dedicated to

DONALD R. ELLEGOOD (1924–2003)

whose humanist vision

at the University of Washington Press

shaped important and beautiful books

for a generation.

For "The Beggar's Bag" (Book 1, Fable 7), "I have created a brown paper shopping bag silk-screen printed with old-fashioned images of snacks and other vices that offer a quick fix in the street. . . . These are all things that give us pleasure, but can also be harmful if taken in extremes. The bag itself is also pretty and new, although the demise of a shopping bag is a quick death into the garbage. It is here that I would like to draw a connection to La Fontaine's idea that we see only the good in ourselves, while concealing our negative traits and projecting them onto others. Heaven forbid that we should reveal our potentially self-destructive or needy tendencies, for example."

Allison Smith, USA

"All prudes, all censors, all pedants,
Will recognize themselves in what I'm saying . . ."

"The Fables of La Fontaine are edifying because they do not preach. The lamb will be devoured by the wolf, the grasshopper will croak of hunger, etc. Children, like adults, know that this sounds right. In "The Child and the Schoolmaster" (Book 1, Fable 10), the respective roles are well-balanced, but for once the weak one wins out—this sometimes happens in life. But the duality of the poet touches me because not only does it illustrate two opposite views of the world, like most of the other Fables, but it allows that tomorrow the child might in turn become the schoolmaster and that the latter used to be perhaps like the impudent child.

In La Fontaine we can always identify with one or the other side. If our sense of justice, our compassion, makes us lean toward one side, honesty reminds us that we often are closer to the other."

Camille Saint-Jacques, France

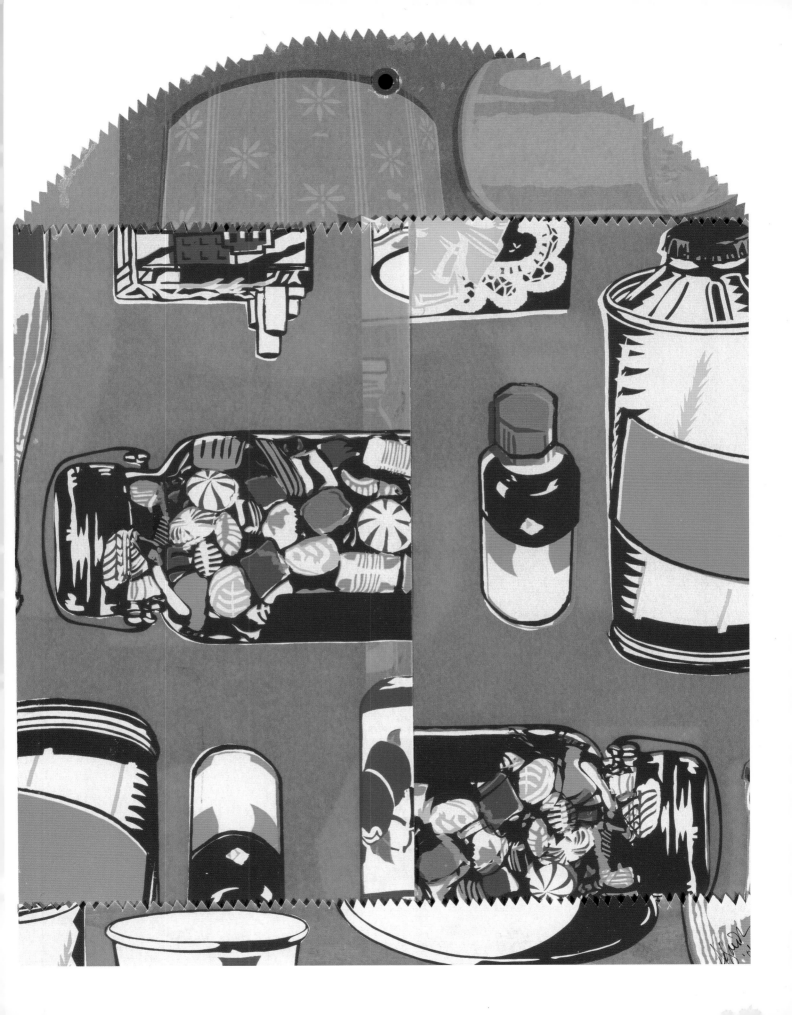

CONTENTS

THE FABLES PROJECT

KOREN CHRISTOFIDES

London, 1996. The Royal Academy of Arts, *Drawings from the Thaw Collection of the Pierpont Morgan Library* (New York). I was instantly drawn to an image by Honoré Daumier entitled "The Schoolmaster and the Drowning Child." The catalogue of the exhibition stated that in 1855 Daumier and a group of artists wanted to produce a new edition of the fables of Jean de La Fontaine, with each artist contributing several illustrations. Daumier's project was never realized. Several years prior to my seeing this image, I had taken part in an exhibition curated by a group of women artists who had asked other women artists to create one hundred "retablo" (*ex-voto)* paintings; following that inspiration, I thought that this project of Daumier's was an interesting idea.

In 1997 I moved from Seattle, Washington, to Aix-en-Provence, France. There I met Ken Tisa, director of the Center for Art and Culture, and Robyn Chadwick, artist in residence, and we decided to curate an exhibition based on La Fontaine's *Fables*. We three artists invited artists, who in turn invited other artists, to illustrate a fable of his or her choice. As the artwork was to be both a traveling exhibition—Aix-en-Provence, France; Rome, Italy; Seattle, Washington; and Baltimore, Maryland—and a publication, we set a standard format of 8 × 11 inches for all illustrations. Apart from that one requirement, painters (both figurative and abstract), poets, photographers, digital artists, conceptual artists, public space artists, ceramists, printmakers, comic book artists, video artists, and art historians were free to interpret their fable as they wished.

This book is the natural outgrowth of that project. The exhibition comprised far too many artworks for all to be published: and the question was how to choose. With a few exceptions of old favorites, such as "The Grasshopper and the Ant," the fables selected for this volume represent a rediscovery of forgotten tales. A common refrain from the French audience was: "But we *thought we knew* the fables of La Fontaine!" The rarity of these choices of the artists derives from the fact that most of them didn't know the fables either. They chose a fable simply by its intriguing or alluring title. Translations were provided for artists who needed them.

In consequence, this is *not* the handful of fables that French-speaking children still learn in school today, because another of our criteria was to *not* create another children's book. Children may enjoy this book, as children enjoyed much of the art in the exhibition. Nevertheless, through fables such as "The Animals Sick from the Plague" or "The Wolf and the Hunter," one realizes that the fables were never just "little animal stories" written for the young. That the "morals" of the stories often raise more questions than they answer (La Fontaine is never an "old scold") supports the notion that "one has to have lived for a while to fully appreciate the genius of La Fontaine." This was another comment from the French audience. Actually, this book closes with the story of "The Matron of Ephesus," which counts among the fables but is often listed among *Les Contes* of La Fontaine, the erotic tales.

In keeping with the diverse spirit of the artwork, created by artists who come from various places across the United States, several European countries, and Asia, the reader will hear two voices in the translations. Constantine Christofides, a scholar of seventeenth-century French literature, retells the fables in lively prose that is both cutting and adroit. Christopher Carsten, a poet, subtly recalls the beauty and the engaging wit of the original poetry of La Fontaine in contemporary verse and rhyme. These mordant tales are sublimely humorous and, when necessary, quite sad. As great art always will do, the *Fables* cast a sharp light on our own time.

Marc Fumaroli has remarked that "Art saves art," suggesting that a "relay" of sorts keeps great art alive and moving forward in time. Indeed, Jean de La Fontaine drew his inspiration from the deep well of antiquity and brought forward into his own time the arts of Aesop, Homer, Phaedrus, and Ovid, as well as old oriental tales later published in Europe (1704–17) as *The Arabian Nights.* We, in creating this book,

FACING PAGE *The Wishes/Les Souhaits (Book vii, Fable 6), Tony Wong, China/USA*

xv

are inspired by the seventeenth-century poetry of La Fontaine and have brought to fruition the dream of the nineteenth-century artist Honoré Daumier. Such is the wealth and depth of the fables that, without a doubt, these stories will be retold and re-illustrated in the future, and we hope that this edition of *Fables of La Fontaine* will inspire a next generation of artists.

LA FONTAINE

From Animal Allegory to Tragic Vision

CONSTANTINE CHRISTOFIDES

"Truth herself has spoken in parables, and what is a parable but a fable? That is to say, an imaginary episode used as an illustration, all the more penetrating and effective because familiar and usual."—La Fontaine

Jean de La Fontaine (1621–1695) WAS BORN AT CHÂTEAU-THIERRY, between Paris and Reims. A reluctant student, he was educated by the Oratorians, who trained future teachers or preachers, but he opted instead for his father's profession as administrator in *Eaux et Forêts*, a sort of forest service. When that post was suppressed, the spendthrift La Fontaine followed the contemporary tradition of artistic patronage, entering in service (1651–1661) to Nicolas Fouquet, the powerful superintendent of finances. La Fontaine extolled the fairy-tale, oneiric atmosphere of Fouquet's Vaux-le-Vicomte, an estate of shocking magnificence that anticipated the splendors of Versailles and influenced the young Louis XIV to bring about Fouquet's disgrace in 1661 through trial, imprisonment, and exile, barely sparing his life. La Fontaine's unswerving gratitude and loyalty to Fouquet, in the aftermath of the fateful *fête* of the night of August 17, 1661, provides a possible key to the moral and philosophical climate of the *Fables*.

In his preface to the first six books of the *Fables*, appearing in 1668, La Fontaine acknowledged his debt to the Greek Aesop and the Roman Phaedrus, much as he had avowed a debt to Ariosto and Bocaccio in

his bawdy and erotic *Tales* of 1665, aimed at a a popular audience and in accord with the medieval Romance or Rabelaisian tradition. The 1670 edition of the *Fables* was dedicated to Louis XIV, who had been diffident toward La Fontaine on account of his loyalty to Fouquet and the publication of the irreverent *Tales*. (The last edition of *Selected Fables* was printed in 1693, with a 1694 date.)

In 1672 Mme de La Sablière became La Fontaine's patron. By 1674 Mme de Sévigné found in the fable of "The Lion" (XI, 1), which has affinities with "The Animals Sick from the Plague" (VII, 1), a delightful allegorical recognition of the Court. It is ironic that when Colbert, Fouquet's implacable enemy, died in 1683, La Fontaine's name was proposed to fill his vacant seat at the French Academy. Agreeing never again to publish anything of doubtful morality, like his *Tales*, La Fontaine was elected to that body in 1684, with the King's consent. The 1689 dedication of some fables to the Duke of Burgundy, elder son of the Dauphin (himself the recipient of a dedication that had pleased his father, the King), suggests the importance of tutorial posts in the education of princes (Bossuet, Fénelon).

Both Molière and Racine admired their younger contemporary. They knew that he was inventing a new form of poetry, simple and ingenious. They also recognized his debt to Renaissance humanism that had fed on the Ancients and Epicureanism against the persisting religious or Christian backdrop. His indulgent ethics penetrate the heart without wounding it, thought Chamfort. This is perhaps why readers who lived outside the conventions of Louis XIV's court rallied to him, appreciating his shared skepticism, in the line of Montaigne, who had asked: What do humans know, *what do I really know?* But these same readers also relished in La Fontaine's writing the alliance of song with prudence, gentle malice, and common sense.

The *Fables* immediately entered French collective memory, where they have maintained their place through the ages, right to the present day. (To La Fontaine's delight, Fénelon, preceptor to the Duke of Burgundy, assigned them as lessons to his young pupil.) While Rousseau saw "immorality," successive ages have seen irony, profundity, supreme originality of expression, satire and delicious black humor. Far from being the "corruptor of souls" (Bossuet), La Fontaine, the last exponent of the lyrical poetic movement of the French Renaissance, progressively bestows a lyrical voice on human *ennui* or spiritual crisis, a theme fundamental to French thought from Pascal to Baudelaire. In this century of absolutism, he also succeeds, through sardonic evaluation of historical events, in a daring alignment of animal allegories with conventions of epic or tragedy, as in the fable of "The Two Goats" (XII, 4).

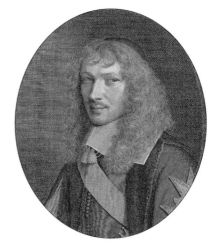

Nicolas Fouquet, gravure by Robert Nanteuil (1623–1678). Courtesy of the Bibliothèque nationale de France, D 143290

The French seventeenth century was an age of tragic vision, an age of questioning who we are and what our fate is in relation to ourselves and our human nature, often in terms of the newly established mathematical and astronomical ideas concerning the infinity of the universe (Descartes, Pascal, Galileo). La Fontaine's vision of the human condition, reflected in the *Fables*, presents in compressed poetic form (like myth), a world view anchored in a personal meditation that goes on to assume political and ethical dimensions, as his own cultural situation melds with that of the society in which he lives.

The two roads that he constantly faces and before which he always hesitates (as in "The Grasshopper and the Ant" [I, 1] or in the image of the Butterfly and the Bee, which he uses, in a *Discours* to Mme de La Sablière, to define his art) betoken the dilemma of his search for dazzling beauty and his search for substance. When he surveys the social and political scene, he recalls the pliant Reed versus the unbending Oak in a shadowless culture where lives are made or scorched by the unavoidable Sun King. And in this Spanish Court (Anne of Austria, the King's mother and Maria Teresa, his wife, are descended from Hispanic royalty), his folk wisdom suggests that Spanish eccentricity, as opposed to French regularity, may not be all that outlandish (see "The Rat and the Elephant" [VIII, 15]).

His greatest fables, then, become mordant parables. Oscillating between Olympus and Parnassus, in Marc Fumaroli's phrase, La Fontaine proclaims his passion for the freedom to think like a modern man, which he contrasts with the servile hypocrisy of the nobles in the court of that arch absolutist, Louis XIV.

The entire seventeenth century crafted "moral systems" which today would be classified as theories in the social or human sciences. La Fontaine thus joins the "moralists" of the Great Century, but as a nondogmatic practitioner of high ethical values, ranking friendship above all, and as a believer in a universe, possibly of chance, where the good do not always triumph (though they might), and the bad will often meet their comeuppance (but not always). In the work of this nondoctrinaire "moralist," two opposing views of the world and the cosmos are ever present.

The animals in the 243 fables are one aspect of the work, perhaps the major aspect. As La Fontaine's candidacy for the French Academy neared, however, the animals were replaced in center stage by humans. Nonetheless, the animals never cease their discoursing, as if they are interested in the same things as the powerful humans—nobles and moneyed bourgeois—who run the country. Sometimes La Fontaine uses fables as allegorical springboards to the representation of vexing

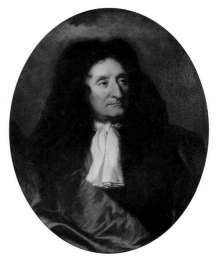

Jean de la Fontaine, portrait in oil by Hyacinthe Rigaud (1659–1743). Courtesy of Musée Carnavalet, Paris, P 2441

political or social questions—but without ever appearing rebellious or dissident. He summons up all his intelligence and tact in an unforgiving and vengeful age, not only to retain the freedom to sing but perhaps also to avoid reprisals.

But ultimately La Fontaine is a poet, and the stuff of poetry is words arranged in a certain compact order. We must seek the quintessence of poetry in his work, as we do in the work of any poet deemed great by posterity. In his case, saying less than it perhaps intends, art becomes to some extent symbolic. The sorrow and the pity, the solitude and sociability, the serious, the comic, the crafty, the voluptuous, all interpenetrate, as when in the fable of "The Hare and the Frogs" (II, 14), the Hare sinks in profound *ennui*:

> Dans un profond ennui
> Ce lièvre se plongeait

The meditations consider the state of our humanity, of course, but they also analyze the French national character at a time when power oscillated between hereditary monarchy, the challenges of the ascendant high bourgeoisie, and European court rivalries. The road-map for the great Revolution, just one hundred years hence, was being drafted.

Simultaneously a lyricist and realist, La Fontaine stood in contrast to the pompousness of the court of Louis XIV. In his Arcadia, where (like Poussin's shepherds) plebeians and animals are literate and communicative, he sought and found an original and singularly universal poetic form—but with smiling Gallic overtones—to sing about Man's Fate. His influence persists in the evolution of the French language that he so patiently enriched—and it permeates French culture today.

In the fable "Against Those Who Have Difficult Taste" (II, 1), La Fontaine sums up his art:

> J'ai fait parler le loup et répondre l'agneau.
> J'ai passé plus avant: les arbres et les plantes
> Sont devenus chez moi créatures parlantes.

> I had the wolf speak and the lamb reply
> I went further: trees and plants
> Acquired speech in my art.

Living things become personifications in an art that both means and is, that laughs while it contemplates with dread the silence of the infinite. His is a large view of the world in which correspondences exist among all living creatures; humans, animals, plants, and trees beckon to us in an attempt to elicit our eternal remembrance, sympathy, and protection.

SOURCES

Jean-Pierre Collinet, ed. *La Fontaine, Œuvres complètes*. Paris: Bibliothèque de la Pléiade, 1991.

Jean de La Fontaine. Catalogue d'exposition (October 4–January 15, 1996). Paris: Bibliothèque Nationale 1995.

Marc Fumaroli. *Le Poète et le Roi: Jean de La Fontaine et son siècle*. Paris, 1997.

Paul Morand. *Fouquet ou le soleil offusqué*. Paris, 1961.

The Fables The Artists

"On La Fontaine . . . you should like him, in French, at least—
so solid, shrewd, tender, unromantic, worldly wise, full of people—
hard and soft where he should be—a perfect craftsman."
—Robert Lowell to Elizabeth Bishop

The Grasshopper and the Ant

BOOK I, FABLE 1

La Cigale et la Fourmi

Fay Jones, USA

The Grasshopper, having sung all summer,
Found herself penniless
When the windy season came.
Not a trace of worm or fly.
"I'll starve," said she to
The Ant, her neighbour,
Begging it to lend her
Grain or seed so that she
Could survive till spring.
"I'll repay you before August,"
Said she, "—with interest—
Upon my word as animal."
The Ant is not an easy lender:
It's the least of her flaws.
"And what were you doing
During the hot weather?"
She asked the would-be borrower.
—"Night and day
I sang my heart out to all."
—"You sang? Great!
Now, dance!"

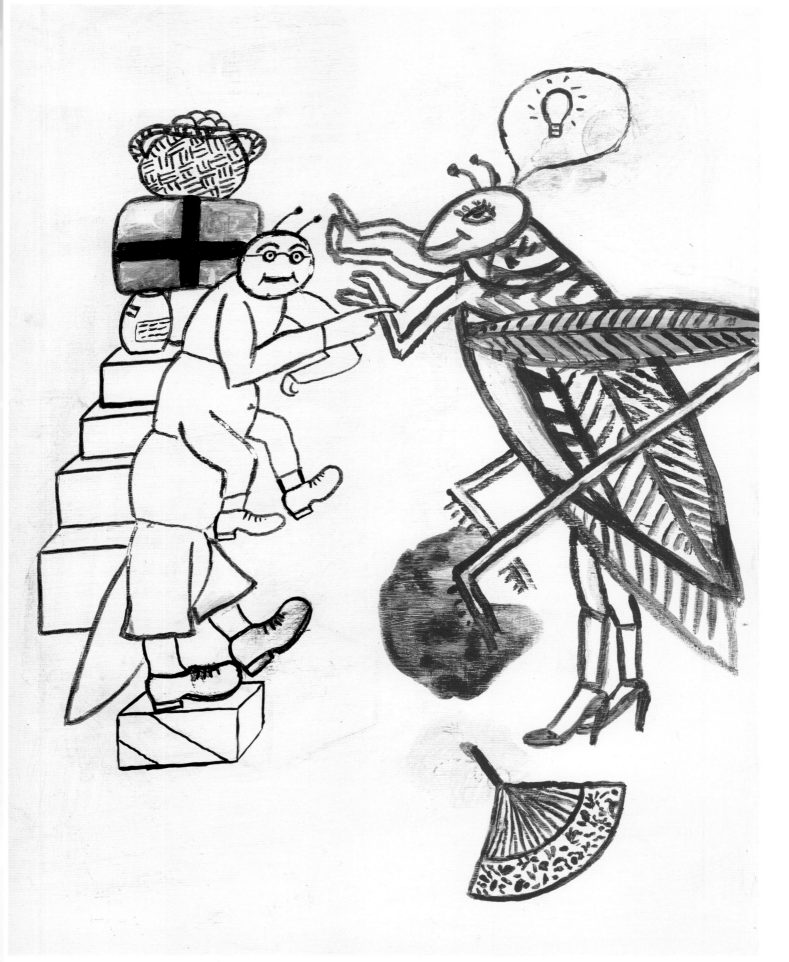

The Frog and the Ox

BOOK I, FABLE 3

*La Grenouille qui veut se
faire aussi grosse que le Bœuf*

Harvey Daniels, England

There was a Frog who saw an Ox
 As massive as he was robust.
No bigger than an egg herself, she must
At once be like him. Envy talks
In every gesture. With a huff and a puff
 She says, "Now tell me what you think, Sis;
How's this for a start? No? Not enough?"—
"Nope."—"How 'bout now?"—"No way."—"And this?"—
"Not even close." Though confident at first,
 Poor little froggy huffed so much she burst.

Folks today show symptoms of her flaw:
Like Pharoah, this one bids
The raising of glass pyramids;
For every senator, *"L'Etat, c'est moi,"*
And all those tiny governors, though dopes,
 Nurse presidential hopes.

4

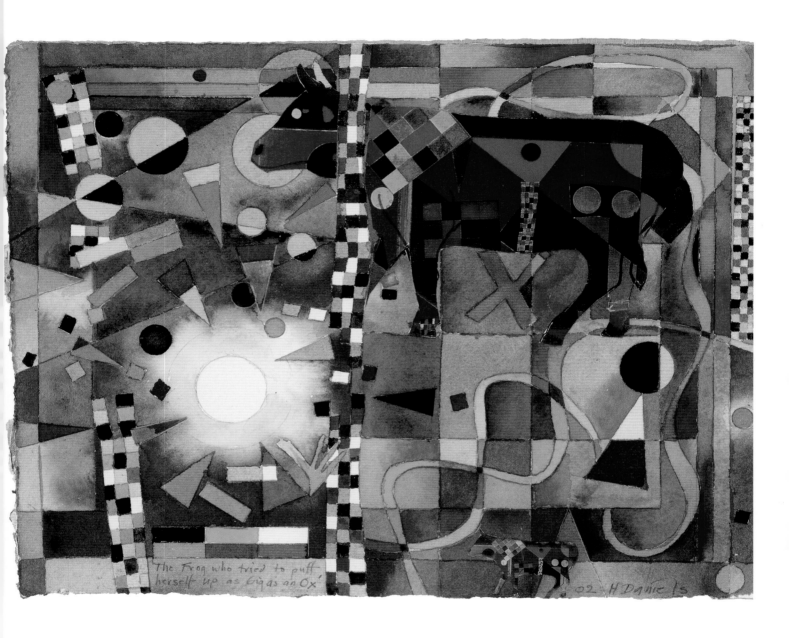

'The Frog who tried to puff
herself up as big as an Ox'

02—H Daniels

The Beggar's Bag

BOOK I, FABLE 7

La Besace

Laura McCallum, USA

Said Jupiter one day: "Let every breathing creature
Come gather round the toenails of my grandeur.
If anyone's unhappy with his size (or nose or ear),
 Let him speak without fear,
 For I will make amends.
You first, Monkey (what a sight!). Come tell your friends
 About their looks; do they compare with yours?
Are you content?"—"Who me? Of course I am.
I too have four feet like the rest of them.
My portrait, Sire, reflects perfection's charm,
But, as for brother Bear, *who's* got the craft
To make a painting out of that rough draft?"
The Bear gets up; all wait for a dark complaint.
Far from it. Praising himself without restraint,
He scorns the Elephant's ungainly plight:
"Add to his tail! Take something off the ears!
Revise," he says, "that unbecoming fright."
 The Elephant now ponders what he hears,
And, though considered wise, speaks like the Bear:
 Observing how she eats, he judges that
 Madame the Whale is verily too fat.
Dame Ant demeans the Mite as scarcely there
 While she herself is statuesque.
Old Jupey damned the lot, dismissed them all—
Each self-deluded beast. Yet more grotesque,
Our species takes the cake. With patent skill
 We give ourselves full pardon, then
 Deny it when it comes to other men:
 For them we're eagle-eyed,
 But for ourselves, as blind as bats.
 The Sovereign Maker made us, past
 And present, into beggar's bags:
 He put a pouch for our defects in back,
 And then, to balance out the cosmic laws,
 He put one up in front for others' flaws.

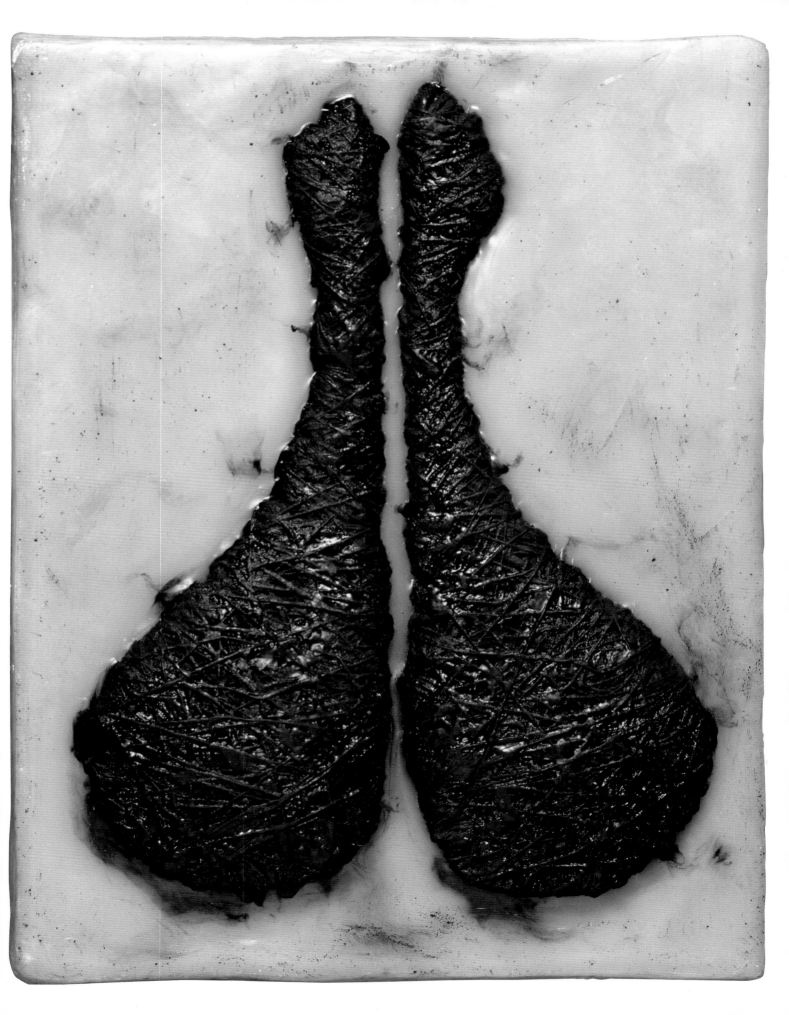

The Man and His Image

—*For Monsieur le Duc de la Rochefoucauld*

BOOK I, FABLE 11

L'Homme et son image

Dan Meyers, USA

A Man without rivals, who liked himself,
Thought himself the most handsome man in the world.
He accused mirrors of being false
And lived happily with his illusions.
In order to bring him to his senses, Fate
 Lined up everywhere
Mirrors that ladies use, that houses use,
 That vain gentlemen
 Keep in their pockets.
So what does our Narcissus do? He hides in the dark,
Avoiding the judgment of mirrors.
But an out-of-the-way, clear water stream
 Shows him his reflection
 And makes him mad.
Pretending that his eyes are seeing a Chimera,
He does his best to avoid this water,
 But the stream is so beautiful
That it's hard to ignore.
You get the drift of my point, because I'm
Addressing all of you; this extreme illusion is a common fault.
Our soul is the Man in love with himself;
Mirrors are the errors of others;
 As for the stream,
It's as we all know, *The Book of Maxims.**

*The Book of Maxims of La Rochefoucauld was published in 1664.

8

The Dragon with Many Heads and the Dragon with Many Tails

BOOK I, FABLE 12

Le Dragon à plusieurs têtes et le Dragon à plusieurs queues

Dana Prescott, Italy

One day at the Emperor's,
An Envoy of the Great Lord said that he favored,
 According to History,
The forces of his master over those of the empire.
 A German started to say,
 "Our Prince has followers
 Who are so powerful
 That each could raise an army."
 The Turk, a man of sense,
 Said to him, "I know via hearsay
That each elector can contribute soldiers,
 And this reminds me
Of a strange adventure, which nonetheless is true.
I was in a safe place when I saw go by
The hundred heads of a Hydra across the hedge.
 My blood froze,
 And I believe that I controlled myself,
But one cannot experience fright without feeling bad.
 Never did the actual animal
Come near me nor find it's way to me.
 I was thinking of this adventure
When another Dragon, who had only one head
But more than one tail, showed up.
 Here I was, once again,
 In fear and astonishment.
This chief goes by, body and tails.
Nothing interfered with them, the one passed by the other.
 This, I maintain, is how things are
Between your Emperor and ours."

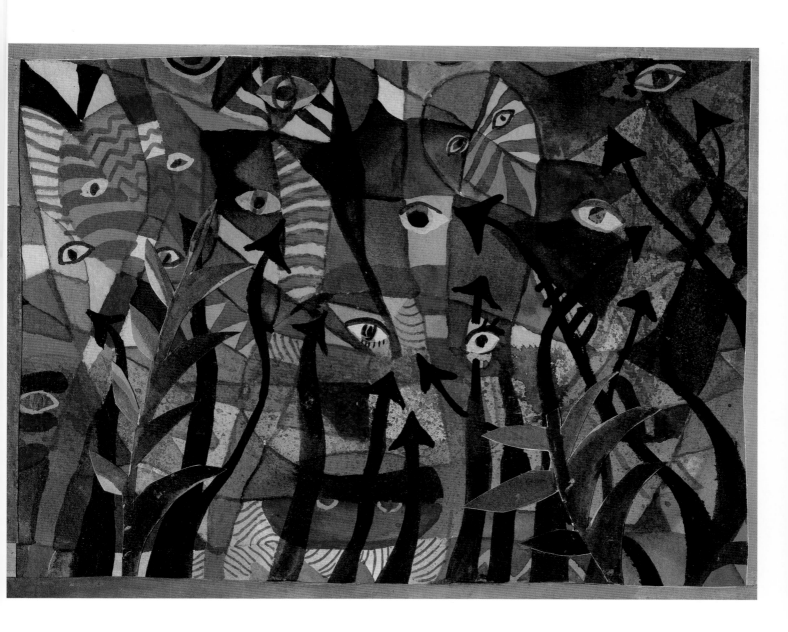

Death and the Woodcutter

BOOK I, FABLE 16

La Mort et le Bûcheron

Louise Kikuchi, USA

A poor Woodcutter, bent under
The weight of both faggots and age,
Takes heavy steps as he struggles to reach
His smoked-out hut.
Finally, crushed by his load and by pain,
He puts down the bundle of firewood and
Starts thinking about his unhappy life:
"How much pleasure have I ever gotten since I was born?
And could there be anyone more poor than I on this earth?
Even bread is sometimes scarce, and fatigue plentiful."
His wife, the children, the rampaging soldiers,
Taxes, moneylenders, drudgery
—these things complete the picture of his being.
He summons Death; she comes without delay
And asks him what he wants.
 "It's help I need
To reload my burden—it won't take long."

 Death heals all,
 But we don't budge:
 We would rather suffer than die.
 It's humanity's motto.

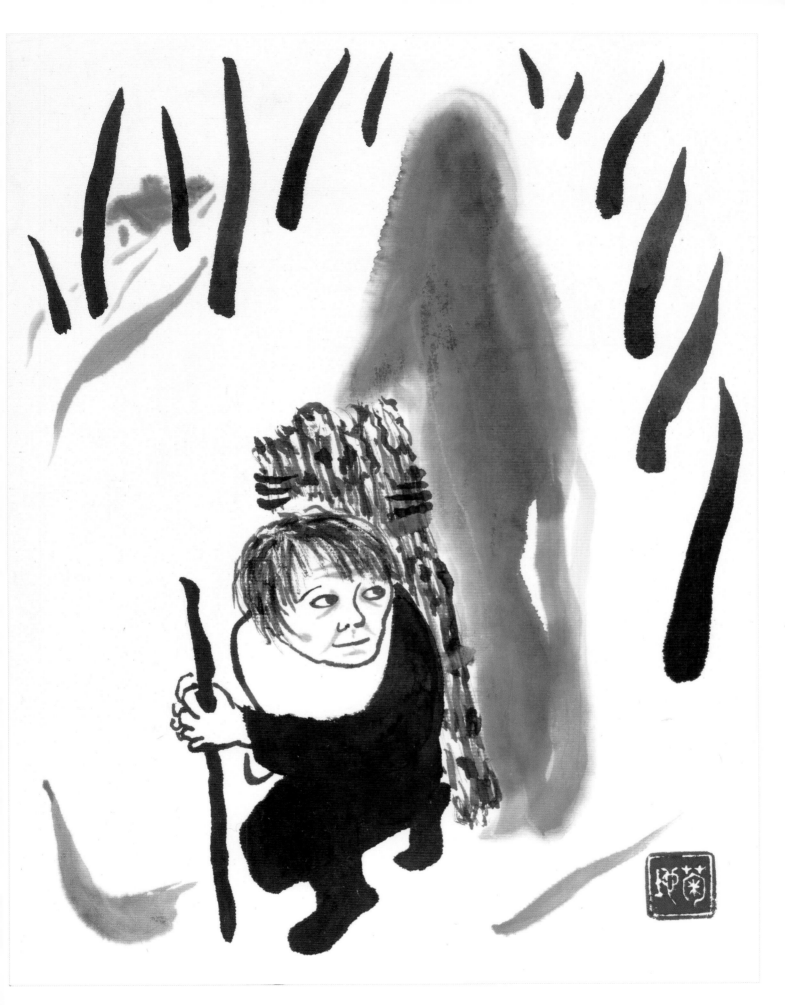

The Man between Two Ages and His Two Mistresses

BOOK I, FABLE 17

L'Homme entre deux âges et ses deux Maîtresses

Roger Shimomura, USA

A middle-aged man going grey
Thought that it was time
To think about marriage.
He had some money,
So he had choices: women were interested in him;
And thus our Lover was in no hurry;
But to be at the right place to choose is not that easy.
Two Widows seemed to be close to his heart:
One was still young, the other a bit older,
But they knew how to repair
The ravages of nature.
These two Widows, while chatting
And laughing, were fun for him,
And now and then they fixed his hair;
That is to say, made him look better.
The Old One would snitch
A bit of the dark hair that he had left;
The Young One would pull the white hair,
And both did so well that the grey head
Became hairless, and he had his suspicions.
"A thousand thanks my pretties,
I have gained more than I have lost;
But as for marriage, I have made no decision.
Both of you want me to live
According to your ways, and not mine.
A bald head thinks quite well alone.
I am most obliged, my Lovelies, for this lesson."

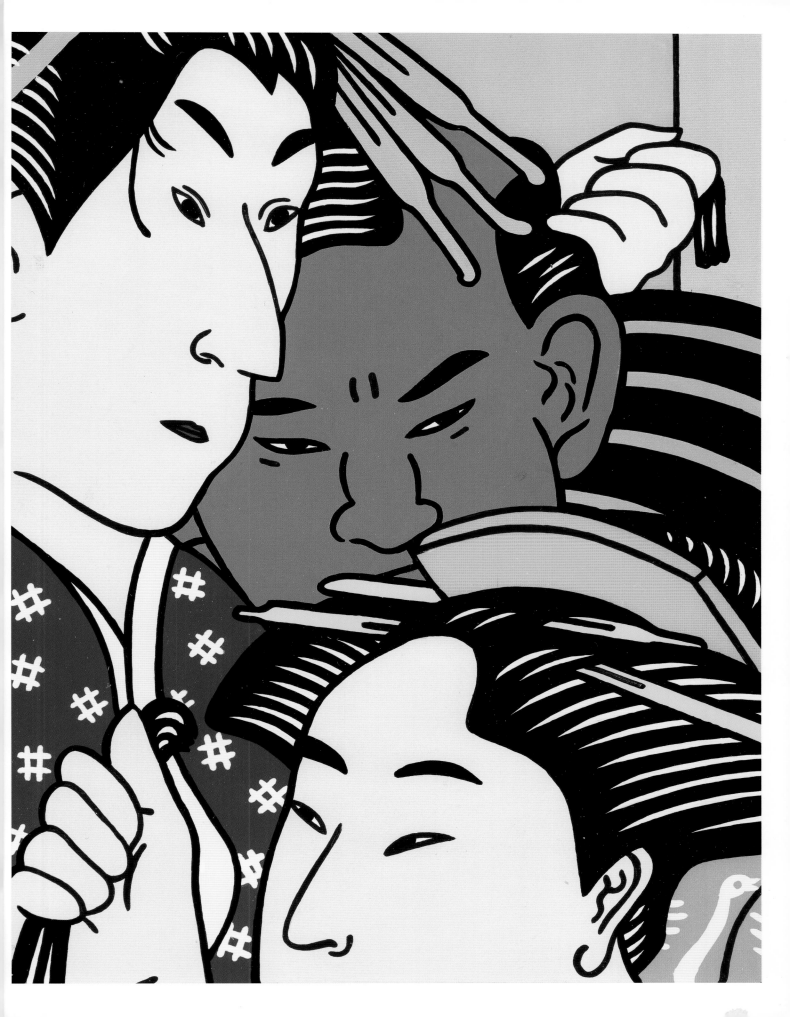

The Child and the Schoolmaster

BOOK I, FABLE 19

L'Enfant et le Maître d'école

Camille Saint-Jacques, France

In this tale, I propose to reveal
The vain thesis of a certain fool.
A young child, while trotting on the banks
Of the Seine, fell in.
Heaven be thanked, a willow's branches trailed
Low in the river. And thus God saved him.
Caught, as the child was, in the branches,
A Schoolmaster happened by;
"Save me! I'm drowning!" cried the desperate child.
The Teacher, responding to these cries,
Dressed him down in a serious tone:
"Ah, the little monkey!
Look how far stupidity took it!
And to think that one must babysit these rascals.
How unhappy the parents' task,
Keeping an eye forever on such fools!
I really feel sorry for them with these constant headaches!"
Having thus railed, he pulled the child to safety.
I blame more people than you think.
All prudes, all censors, all pedants,
Will recognize themselves in what I am saying;
These three categories comprise countless numbers
Of blessed windbags
Who, in all they do, make sure to manipulate language.
Hey, my friend, first pull me out of danger;
And then continue with your verbiage!

XLV 157

A Council Convened by the Rats

BOOK II, FABLE 2

Conseil tenu par les Rats

Andrew Johnson, USA

A Cat named Rodilardus
Made such havoc around the Rats
That they became invisible,
So many had he buried.
The few that remained dared not leave their hole,
Barely finding food to eat;
And the Cat was tagged, by this miserable company,
Not as a Cat, but as the Devil.
Now, one day this rascal
Set out to find a lady cat.
The assembled Rats gathered in a corner to confer
While the Cat made whoopee.
First of all, their Chief, a very prudent person,
Offered the opinion that, sooner or later,
They should attach a bell around Rodilardus's neck;
Thus, when he started after them
They would be warned and they would hide.
They all agreed with the Chief
That this seemed the best solution.
The problem was how to attach the bell.
One said, "Not me, I'm not that stupid."
Another said, "I wouldn't know how to do it."
Thus, without doing anything, they parted.
I've seen many councils
Incapable of action,
Councils not of Rats, but of Monks, of Prelates.
At the start of deliberations,
The Court and the Councilors abound;
But when it is time to act,
Everyone disappears.

The Wolf Brings the Fox to Trial Before the Monkey

BOOK II, FABLE 3

*Le Loup plaidant contre
le Renard par-devant le Singe*

Dean Goelz, USA

A Wolf claimed that he had been robbed:
A Fox, his neighbor, who led a pretty bad life,
Was summoned for this alleged theft
Before the Monkey Magistrate to plead,
Not through lawyers, but by each Party.
Themis had never worked,
In the Monkey's memory, at a more embroiled trial.
The Magistrate was sweating in his Justice's quarters.
After all had contested,
Replied, shouted, thrown fits,
The Judge, wiser by their malice,
Said to them: "I've known you both for a long time, my friends;
And both of you will pay the fine:
Because you, Wolf, you complain, even though no one
Took anything from you.
And you, Fox, have often stolen something."
The Judge claimed that, for better or worse,
We should not fail to condemn a crook.

Some commonsensical people thought that this outlandish
 judgment,
Full of contradictions, should be censured; but here I am only
Following Phaedrus, and that is his point, according to my
 opinion.

The Two Bulls and a Frog

BOOK II, FABLE 4

*Les Deux Taureaux
et une Grenouille*

Michael Spafford, USA

Two Bulls were fighting as to which would possess
 A Female Bovine and her earthly space.
 A Frog was heard sighing.
"What's the matter with you?" croaked one of it's kind.
"But can't you see?" said the Frog, "that this rivalry will result
In one of them losing, so that he'll have to abandon this
Flowery countryside, and when he no longer lords it
Over the grass of these prairies,
He'll come to our marshes and take over the reeds,
And he'll push us around and kick us into the water.
Somehow we must suffer because of this fight
That was triggered by Madame Bovine."

This fear was well founded;
The loser Bull went to hide
In their patch of land,
Grazing at their expense, of course,
And squashing frogs
At the rate of twenty an hour.

Alas! At all times the Little Fellow has
Suffered from the whims of the Big One.

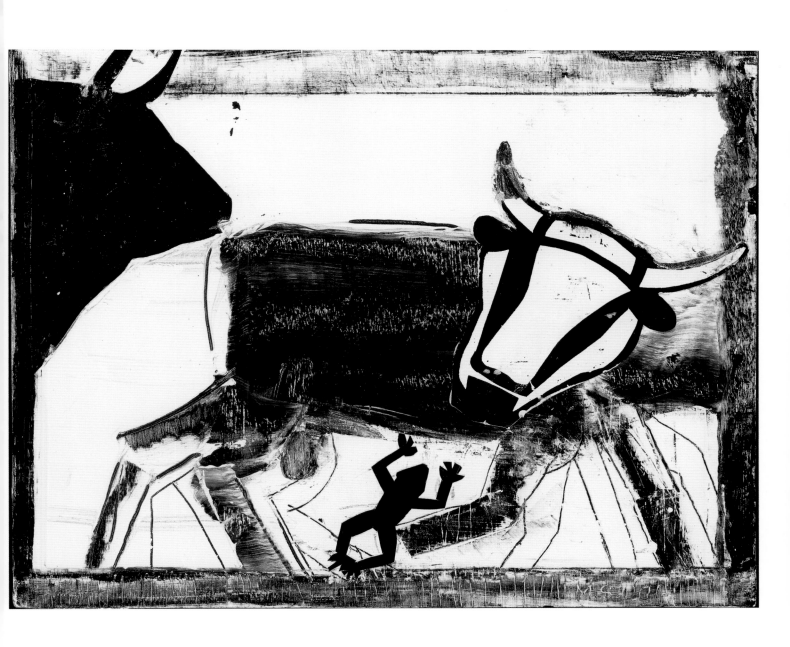

The Bird Wounded by an Arrow

BOOK II, FABLE 6

L'Oiseau blessé d'une flèche

Dianne Martin, USA

Mortally wounded by a feathered arrow,
A Bird was deploring its sad fate,
And said, as the pain increased,
 "Must one contribute to one's own misfortune?
 Cruel humans, you pull out our feathers
 To improve your mortal weapons.
But don't make fun, you despicable, pitiless ones:
Often a fate like ours reaches you.
Half the children of Prometheus' father
 Furnish arms to the other half."

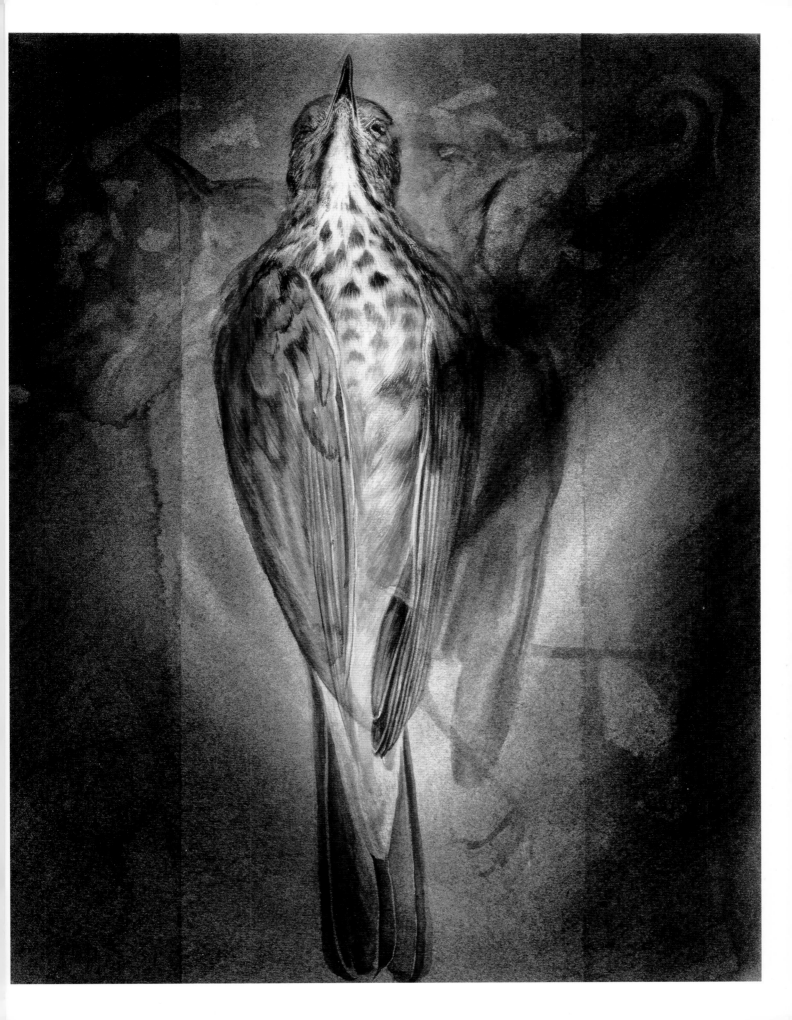

Sponge Donkey, Salt Donkey

BOOK II, FABLE 10

L'Âne chargé d'éponges et l'Âne chargé de sel

Valérie du Chéné, France

A Donkey-driver, scepter in hand
As though he were the Roman Emperor,
Led forth two handsome steeds, both long of ear.
 The one that carried sponges dashed about
 Like a Delivery man no one can thwart;
The other picked his way as if on ice
And had to be beseeched to move his tail.
His load was salt. So, over hill and dale
And on and on our valorous Travelers went,
Until the ford of a swift river,
 Newly swollen, cut their journey short.
 The Driver, who had crossed there time and again,
 Mounted the Donkey draped in Sponge
 And forced the other beast to take the lead,
 Who, doing strictly as he pleased,
 Leapt straight into a water hole and sank,
 Then rose again and clambered up the bank;
 For after several strokes
 His load of salt had melted,
 And the Ass, relieved, no longer felt it
 Burdening his back.
The Spongy Comrade, like a trusting sheep,
Jumped in to follow his example.
So here's our Donkey in the water:
 Up to his neck he plunges,
 He, the Driver, and the Sponges.
All three were soused; the Driver and the Mule
 Were not to be out-drunk
 By simple Sponges.
These latter, heavier and heavier,
Were quickly filled with so much river
That our Ass could no way reach the bank.
 The Driver, all too sure he was about
 To die, clung fast. But someone pulled them out.
Just who this was and so on, who's to care?
But notice how the story with a flair
Transcribes the moral: *"Different strokes
For different Folks."* And that's my point. So there.

TROU D'EAU

TROU D'EAU

The Dove and the Ant

BOOK II, FABLE 12

La Colombe et la Fourmi

Hatem Akrout, France

A Dove was drinking from a limpid stream
When, leaning down to sip, an Ant fell in;
Upon this Ocean, you'd have seen the Ant
Attempt in vain to swim back to the bank.
Our charitable Dove went straight to work:
The blade of grass she tossed into the water
Became the Ant's unhoped for promontory
 And her escape; when, coming out of nowhere,
 A certain barefoot Yokel wandered by
Who chanced to have at hand his bow and arrow.
 No sooner does he see the Bird of Venus
Than he pictures it asimmer in his pot.
But, as my countryman takes aim to kill it,
The Ant comes up and stings him on the heel.
The Peasant jerks his head a smidgen;
The Dove takes wing, and off into the day!
With her, the Yokel's soup has flown away.

 Nothing is ever free . . . not even a pigeon.

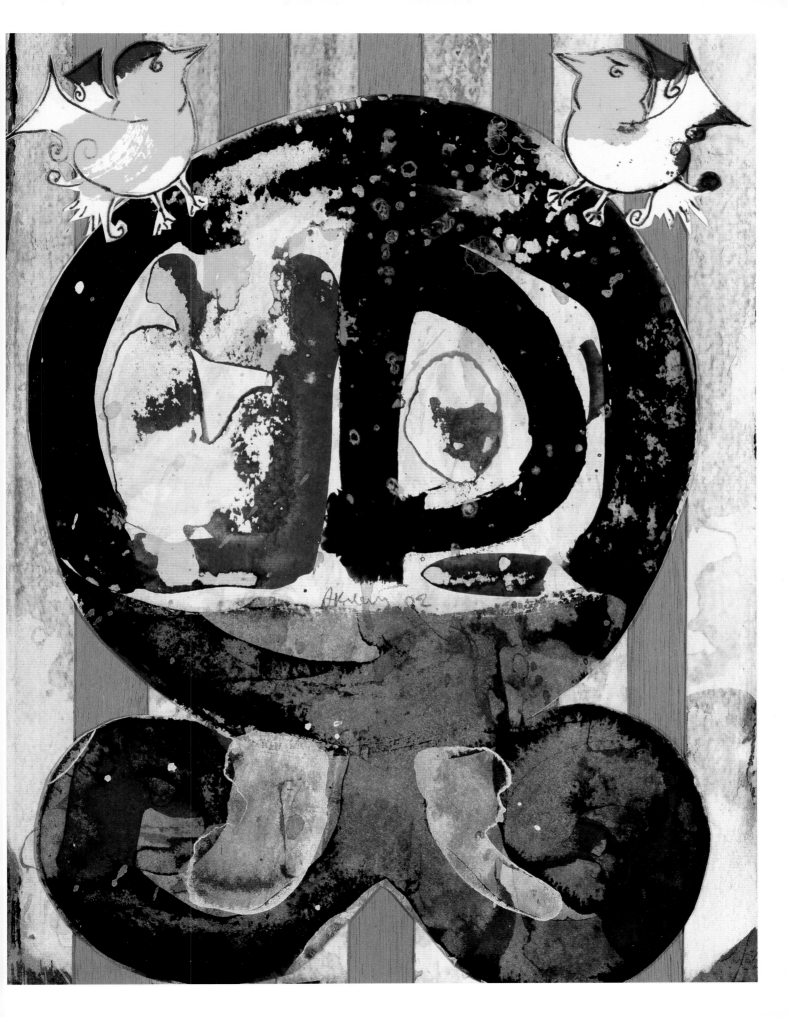

The Hare and the Frogs

BOOK II, FABLE 14

Le Lièvre et les Grenouilles

Harry Bower, USA

A Hare was brooding in his lair
(What else is there to do in a lair but brood?)
And thus this Hare fell into a deep depression.
This animal was sad, and gnawed by fear.
 "Creatures naturally fearful,"
 He said to himself, "are unhappy creatures:
They are unable to seek out what is good.
Always threatened, they never enjoy pure pleasure.
And that is how I live: this cursed dread,
Even in sleep, prevents me from closing my eyes.
Get out of your funk, some wise guy would advise.
 But is it that easy to conquer fear?
 And in all good faith I believe
 That humans are as fearful as I."
 Thus reasoned our Hare,
 And in his vigilance
 He was consumed by fear and anxiety;
A breath of wind, a shadow, was enough to make him shake.
 While considering such fate,
 The melancholy animal
Heard a slight noise: a signal for him
To scurry home to his hole,
Skirting a swamp. The startled Frogs went flying;
Churning the waters they sought the grotto's depths.
 "Well," said Hare, "I've done what others
 Have done to me. My mere presence
 Frightens them! I cause panic in the field!
 What is this source of the terror that I spread?
And is it possible that Animals tremble before me?
 Am I such a thundering enemy?
I realize now that a stark raving coward
Can always find someone more cowardly than himself."

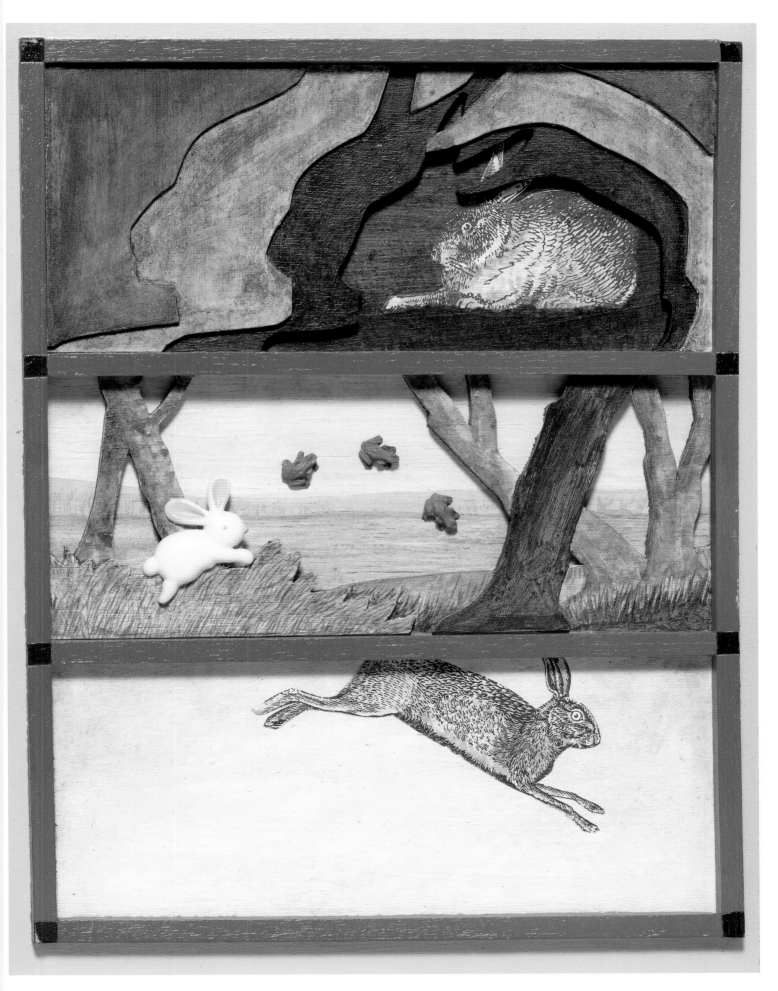

The Crow Who Wanted to Imitate the Eagle

BOOK II, FABLE 16

Le Corbeau voulant imiter l'Aigle

Jesse Bransford, USA

Jupiter's Bird, lifting a Sheep,
 Was witnessed by a Crow,
Who, while weaker than the eagle, had no less appetite.
He tried immediately to do likewise.
He hovered all around the flock,
Spotting among a hundred Sheep, the fattest, the best,
 A true sacrificial lamb:
It was reserved for the mouth of the gods.
Said valiant Crow, with covetous corvine eyes,
 "I don't know who milk-fed you,
But your flesh seems to me just right:
 You'll do as my prey."
And he swept down on the bleating Animal.
The sheep weighed more than a cheese, minus his fleece,
 Which was of extreme thickness,
And curlier than Polyphemus' beard.
It so ensnared the claws of Mister Crow
That the poor Bird couldn't disengage itself:
The Shepherd caught and caged it on the spot,
And gave it to his children as a toy.
One must know one's possibilities.
Flighty creatures make bad thieves.
 Aping our betters is a dangerous trap:
The devourers of men are not all great Lords.
 Where the Wasp moves on, the Gnat stays caught.

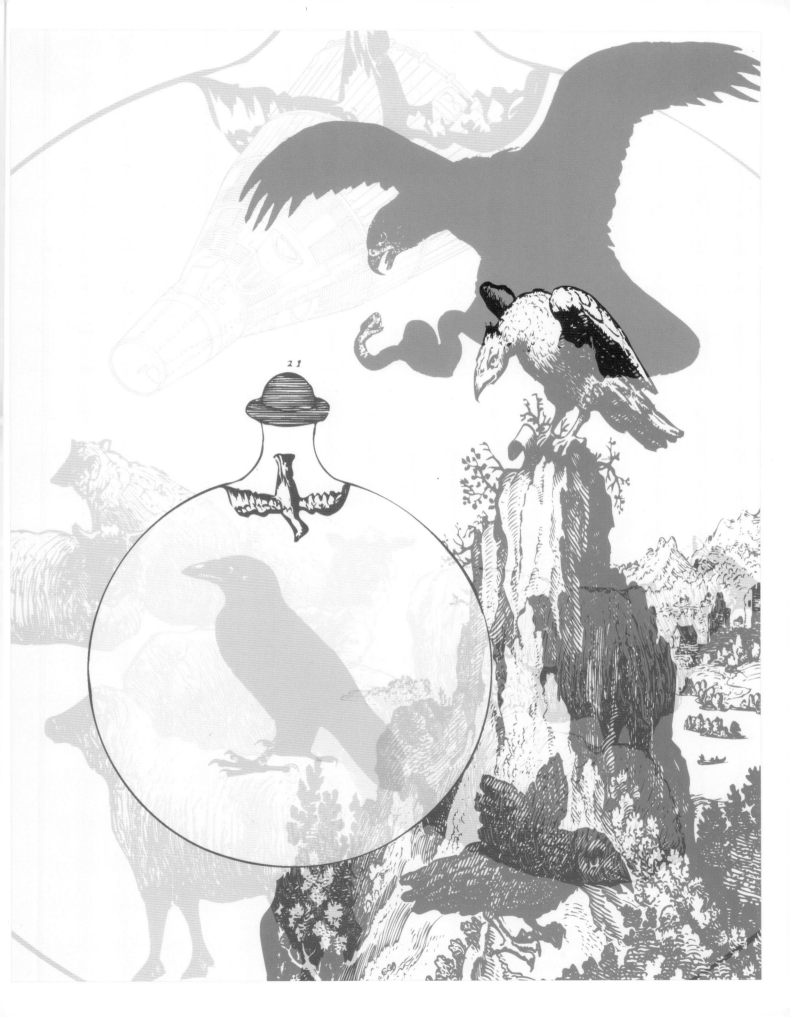

The Cat Transformed into a Woman

BOOK II, FABLE 18

La Chatte métamorphosée en femme

Gene Gentry McMahon, USA

There was a Man who madly loved his Cat;
He found her lovely, darling, delicate—
 For him, her meow was like a gentle tune:
 He was as crazy as a loon.
So one fine morning, desperate and in tears,
 With prayers and spells and the charms of seers,
 Our Man persuaded Fate to change the Cat
 Into a woman, just like that.
 No sooner had the morning eyed the noon
 Than Master Fool had wed his better half.
 Half-cracked before by friendship, now our loon
 Was but a crazy fool in love.
 Never ever did the Fairest Maid
 Enchant her chosen Lover with
 The charms that this Wife, freshly made,
 Beguiled her doting husband with.
 He coaxed her and she flattered him;
 He could see nothing of the Cat within,
 And, far from grasping what was ever true,
 Imagined her a woman through and through—
When, near the bed, Mice gnawing at some threads,
 Disrupt the pleasure of the newlyweds.
In a trice the Wife was on her feet
But failed in her attempt.
The Mice returned, the Wife was crouched up tight.
 This time around she got it right,
 For owing to her wifely transformation,
 The Mice were caught completely off their guard.
 Thereafter, chasing mice was her temptation,
 For it is Nature's instinct to endure,
And past a certain age, there is no cure:
The perfume phial will keep its scent,
The cloth its well-worn crease.
 It would be vain, as we have shown,
 To change an ordinary natural bent,
 And, to reform it, just as rash.
 They say what's bred in the bone
 Will come out in the flesh.
 Arm yourself with club and mace,
 You'll never manage to subdue it.
 Slam the door in its unwanted face,
 It opens up a window and comes through it.

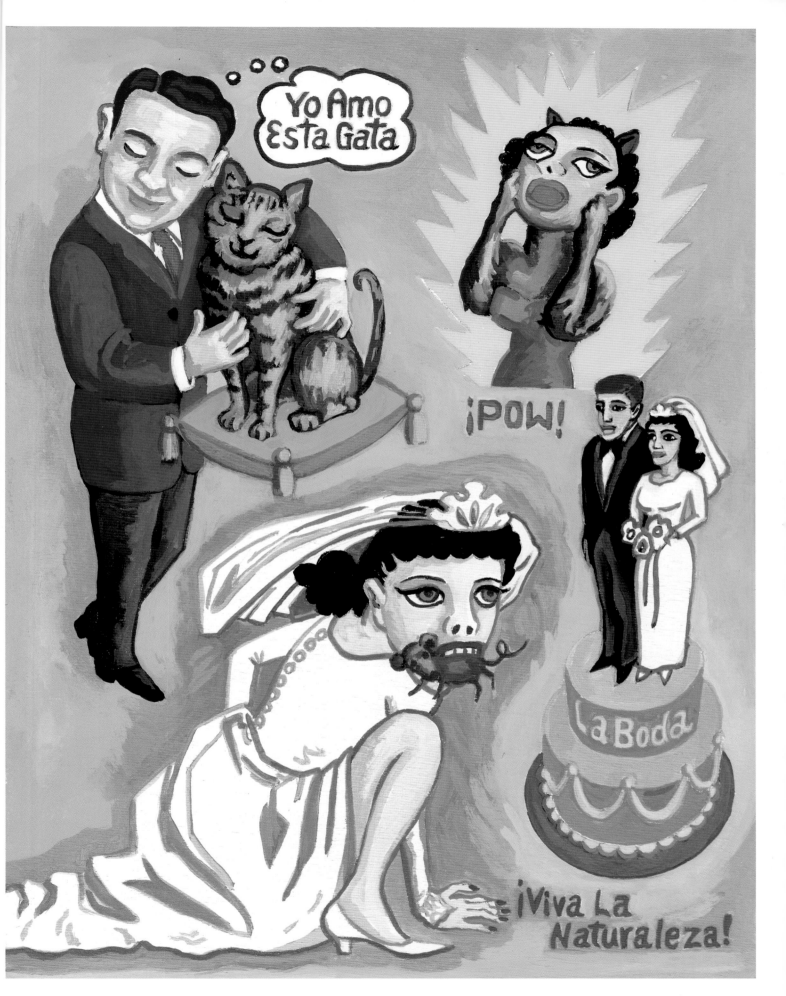

The Limbs and the Stomach

BOOK III, FABLE 2

Les Membres et l'Estomac

Koren Christofides, USA/France

I should have filled these opening lines
With Dignitaries, or perhaps a King,
 But seen from the poetic angle
 A certain Mister Gut shall be our symbol.
He has a need? The whole man feels it.
One day the Limbs were wearing themselves out
In work for him—But what!
Each one, right there, resolved to be a "Gentleman"
And while away the hours, just like Gut.
Said they: "Without our help, he'd have to live off air.
Beasts under heavy loads, we sweat it out.
For whom? For him alone; and where's our cut?
Our every effort goes to swell his gut.
Why not be idle, following his example?"
No sooner said than done. The hands fold gently,
 The arms relax, the legs stop walking.
Gaster was told he'd got what had been coming.
This error they regretted afterward.
Those poor folk soon began to languish;
No new blood formed within the heart,
And each limb suffered, their strength about to vanish.
 This lesson helped the Mutineers perceive
That the one they took to be a lazy man (dead wood)
Gave more than they did to the common good.
The same might well be said of Royal Grandeur.
It takes, it gives, it doesn't feel the difference.
All work for it, and lo!
 All draw from it their sustenance.
It buoys up the artist in his labors,
Fattens the merchant, seats the magistrate,
Stands by the worker, pays the soldier,
Spreading its sovereign grace throughout the realm.
 Long live our sole Protector at the helm!
 Menenius the Wise knew how to say it.
The Council, about to break off from the Senate,
Was fed up with its mighty power and wealth,
Its honors and its dignity;
The people had the gall of poverty,
Debts, taxes, the fatigues of war.
Many were at the outer gates
And on the point of seeking greener pastures,
 When wise Menenius showed to them
 How like they were to the aforementioned Limbs,
And by this Apologue, bright star of the Fables,
He talked them back to their fields and to their stables.

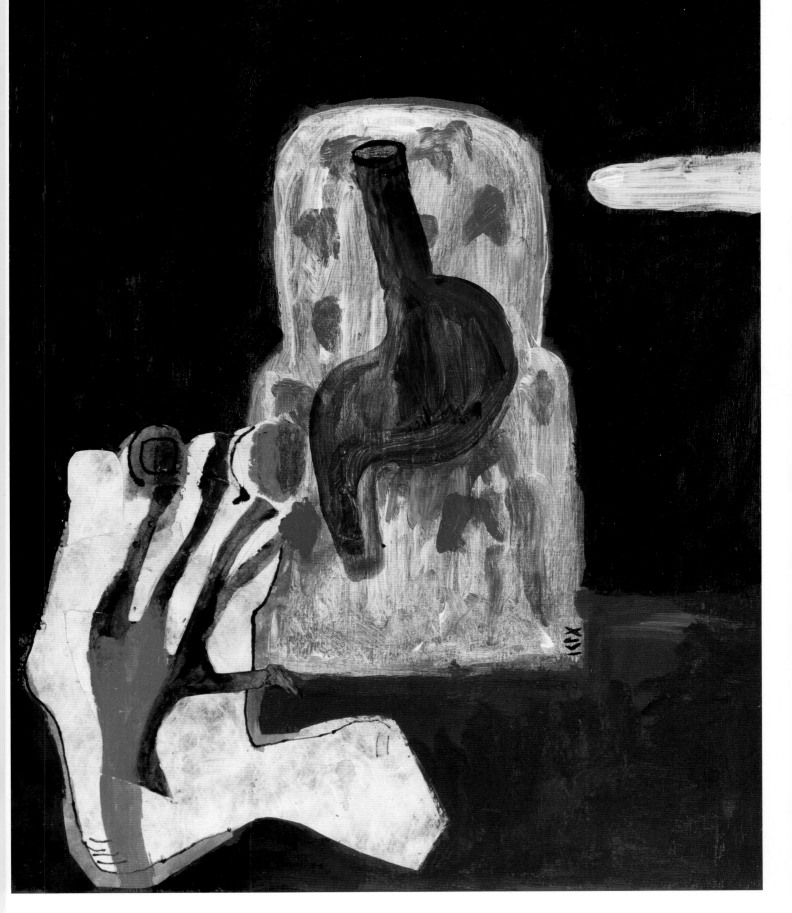

The Swan and the Cook

BOOK III, FABLE 12

Le Cygne et le Cuisinier

Isabella Collodi, Italy

In a Menagerie crowded
With birds,
Lived a Swan and a Gosling:
The one was destined to delight his Master's eyes,
The other, his table. The one was happy to be
Living in comfort in the house, the other in the garden.
In the moat of the Château they would dabble about,
Sometimes swimming together,
Sometimes surfing, sometimes diving.
One day the Cook, having had a bit to drink,
And unaware of their games,
Mistook the Swan for the Goose; and grabbing it by the neck,
He was set to wring it and ready it for the broth.
The Bird, about to die, starts a plaintive song
That truly surprises the Cook,
Who realizes his mistake.
"What! I was ready to put such a songbird in the soup!
And may the gods help me never to cut a throat
That sings so well."

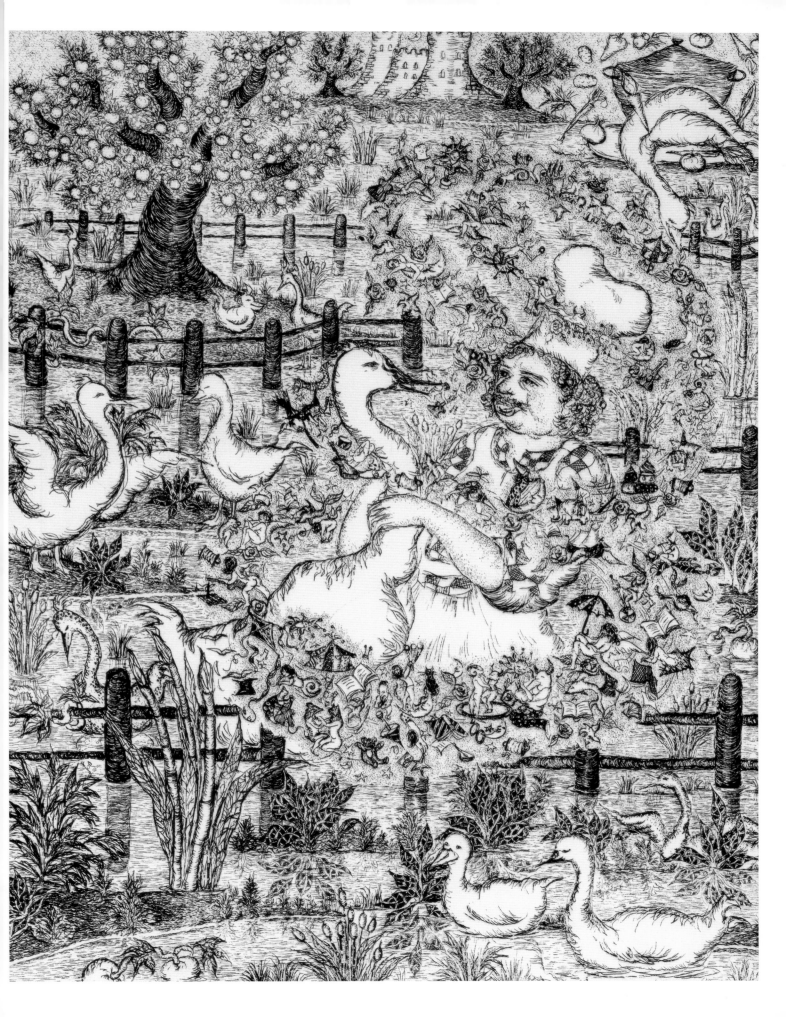

The Wolves and the Ewes

BOOK III, FABLE 13

Les Loups et les Brebis

David Brody, USA

After more than a thousand years of actual War,
The Wolves made peace with the Ewes.
This was advantageous to both parties:
For, if the Wolves happened to eat some mutton gone astray,
The Shepherds would turn some wolves into wolfskin clothing.
 Both pastures and killings would be under control:
But the Ewes would always worry about their rights.
Nevertheless, Peace was concluded; and hostages exchanged.
The Wolves would turn in their Young,
And the Ewes their guard Dogs.
The Exchange was done according to custom,
 And approved by Superintendents.
After a while the Wolf Cubs became adults
And succumbed to the temptation of the palate.
They took advantage of the Shepherds' absence
To strangle half of the fattened Ewes, which they
 Dragged into the Woods.
They had made a secret agreement with their kind,
So that the Dogs, who were sleeping in good faith,
 Were murdered in their slumber.
All of this was done in a flash and painlessly,
So to speak. Not one escaped.
 Our conclusion is this:
One must be in constant war against the baddies.
 Peace may be good in itself,
But what good is it when you deal with untrustworthy foes?

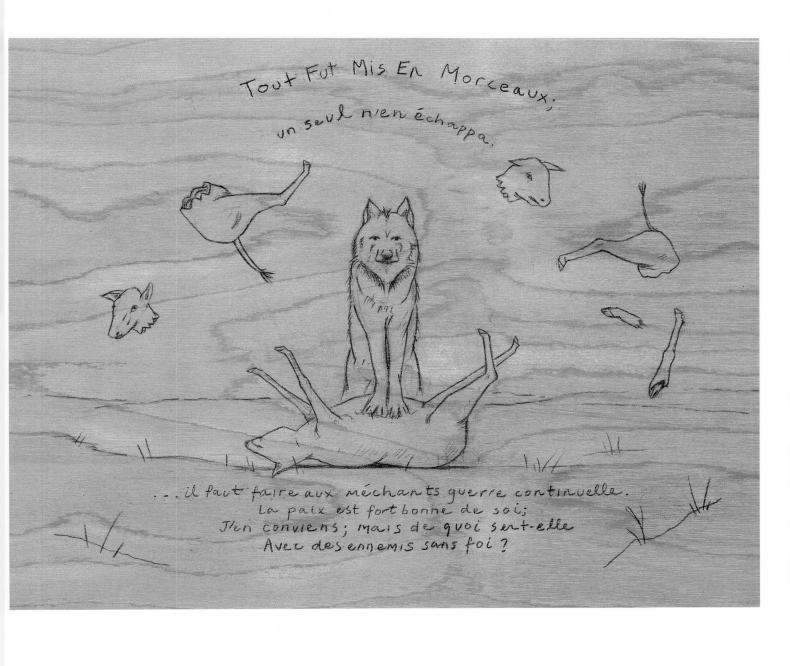

Tout Fut Mis En Morceaux,
un seul n'en échappa.

...il faut faire aux méchants guerre continuelle.
La paix est fort bonne de soi;
J'en conviens; mais de quoi sert-elle
Avec des ennemis sans foi?

The Drowned Woman

BOOK III, FABLE 16

La Femme noyée

Robyn Chadwick, USA/France

I'm not the kind of guy who says: "It's nothing.
 That's just another woman drowning."
I say that's a lot! Their gentle sex is worth
Our most sincere regrets,
For women bring us joy and cheer and mirth.
Now don't imagine that I prate and babble,
 For in this Fable
 There is a wife whose tragic end
Came wet and sudden in a river's bend.
 Her Husband dear went looking for the body
 In order to conclude this cruel event
 With funeral honors, heaven sent.
 It happened that upon the banks
 Of that same River (author of her disgrace)
Strolled two fine fellows at a leisured pace,
Both unaware of her sad accident.
 The Husband came and asked them if, by chance,
They'd seen a trace of his dear wife:
"Not a trace," said one of them, "but try downstream,
 Just follow the direction of the current."
His friend retorted, "No, don't follow it.
 You're better off just going back upstream.
 For though you think the surging race
 Of water must have swept her off and beached her,
 A woman is a contradictory creature
 And would have floated
 Anywhere but there, where she was sent."
This mockery was slightly out of place.
 As for that contradictory temperament,
 I can't quite say if he was right.
 For whether or not we think this humor
 A woman's flaw and natural bent,
 Whoever happens to be born with it
 Will doubtless live and die with it;
 And till the very end he'll contradict,
 And even after . . . were it to conflict.

The Donkey and the Little Dog

BOOK IV, FABLE 5

L'Âne et le petit Chien

Koren Christofides, USA/France

Let's not push our talent;
We would lack grace.
Never would a peasant
Be taken for a prince.
Few men favored by Heaven
Have the gift of Style.
We have to grant them this
So that we won't be like the Donkey of the Fable,
Who, to make himself more endearing to his Master
Went to give him a hug.
"How is it that this Dog, because
He's cute and little," he said to himself,
"Lives as the companion to Monsieur and Madame?
Whereas me, they beat!
What does this Dog do? Lifts a paw,
He gets a kiss!
If that's all it takes to get a pat,
This won't be too bad."
Thinking this admirable thought,
And seeing his Master in a good mood,
He lumbers up, raises his callused hoof
And strokes his Master's chin.
This bold act he follows up
With his own strain of gracious song.
"Ach! What a caress! What a braying din!"
The Master follows with this;
"Donkey Boy! Quick! The stick!"
The stick is applied accordingly;
The Donkey changes his tune.

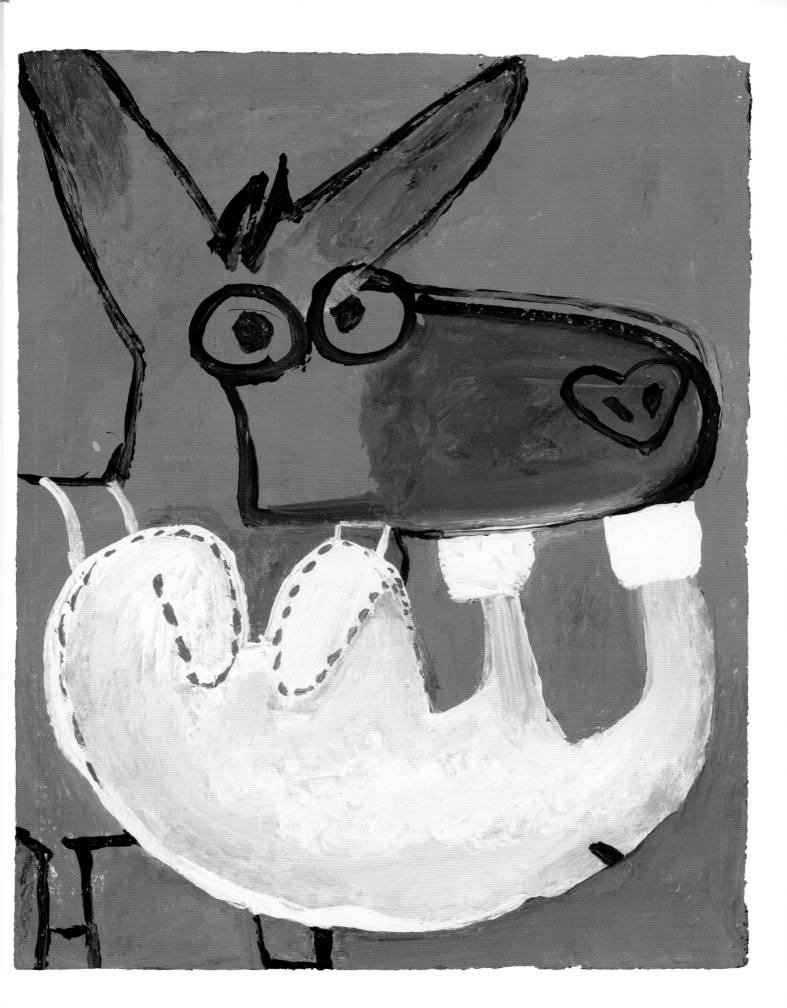

The Man and the Wooden Idol

BOOK IV, FABLE 8

L'Homme et l'Idole de bois

David Atkinson, England/France

A certain pagan kept a wooden god in his house,
The sort of god who doesn't hear even though he has ears.
The pagan nevertheless expected big things.
 It was as if he had three idols.
 It was not only vows and offerings,
But entire oxen crowned with garlands.
Never had a wooden idol dined so well,
Without reciprocation. Indeed, despite
These offerings, neither treasure nor luck
In gambling, no favor at all came his way.
Moreover if some unexpected difficulty
 Arose for some reason or other,
The Man would be in deeper trouble, and
 His purse would suffer accordingly.
 But the god always got his sustenance.
In the end, angered by receiving nothing back,
He took a bat and smashed the idol, only to find
It filled with gold. "When I was good to you
Did you ever give me a penny back?
Go, get out of my house: find other altars.
 You are like those sad, crude
 And stupid people
Who respond only to a big stick.
The more I replenished you, the more empty-handed I became.
It's a good thing I changed my mind."

The Camel and the Floating Sticks

BOOK IV, FABLE 10

Le Chameau et les bâtons flottants

Layne Goldsmith, USA

The first to see a camel
　　Fled before this strange new spectacle.
The second one came closer,
And the third one dared to make
　　A halter for the Dromadaire.
Custom thus makes all familiar,
For that which once appalled the brain
　　Is rendered tame
　　The more we see it.
But this reminds me of a similar instance:
Some guards were ordered to protect the coast,
When, lo! upon the water in the distance,
　　The company was absolutely sure
　　They saw a mighty Man-of-War.
As it approached, the thing became a Fireboat,
　　And then a Skiff, and then a Package,
　　And, finally, just a mess of Sticks and Wreckage.
　　I've met throughout the world
　　Many a one who fits this image:
Far off, he appears to be quite something,
But when you get a look at him, he's nothing.

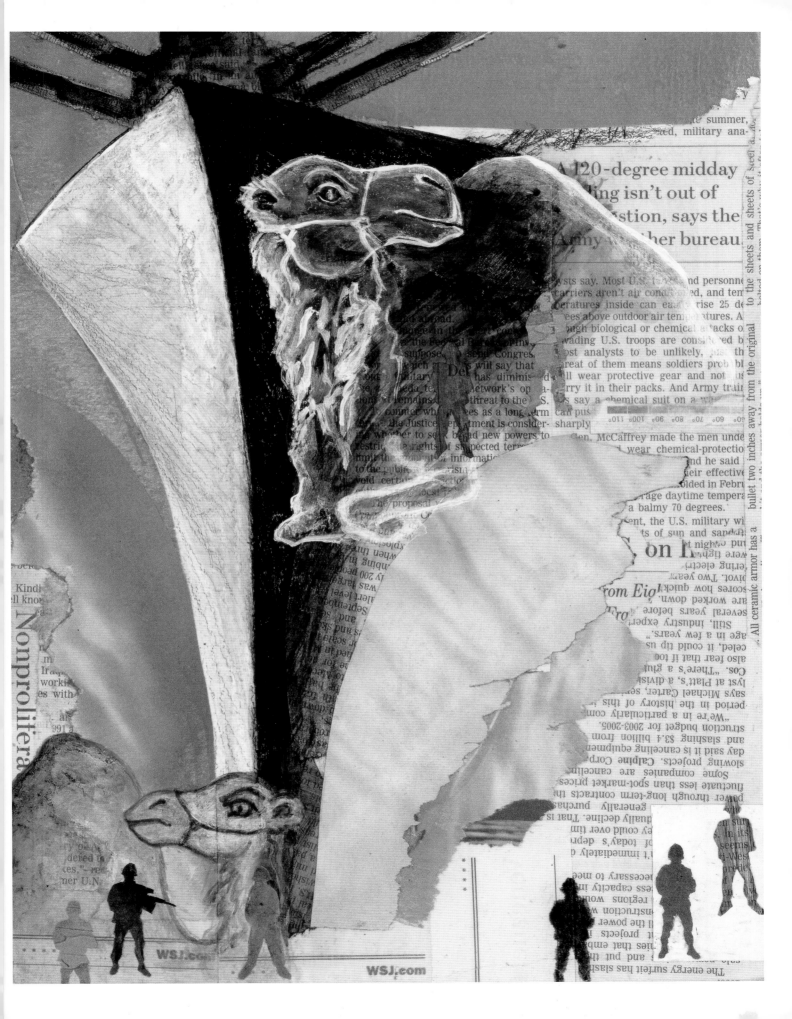

The Frog and the Rat

BOOK IV, FABLE 11

La Grenouille et le Rat

Shirley Scheier, USA

As Merlin says, whoever teaches the other,
 Also teaches himself.
I am afraid this is an old-fashioned saying today,
Though I've always thought it extremely strong.
But to come to my point,
A round-bellied Rat, fat and well-fed,
Who observed neither Lent or any fast day,
On the shore of a marsh was having fun.
A Frog approached and told him, in frog language,
"Come to my place and I'll serve you a feast."
 Sir Rat agreed immediately:
He did not need much convincing.
The Frog tempted him with the prospect of a swim,
Curiosity, pleasure of travel,
A hundred other pleasures offered along the Marsh.
Someday he would tell his grandchildren
About the beauty of this place, the customs of the inhabitants,
And the way the water creatures govern themselves.
There was just one thing that would hold him back.
He couldn't swim well. He needed help.
The Frog assured him she had an answer:
She tied the Rat's leg to her own with a handy twig.
When they entered the water, Our Good Woman
Was obliged to drag her Guest to the Marsh's bottom,
Against all human law and everything she had promised,
Pretending that she would give him a hot meal
(She was thinking that he would make a fine morsel).
In her mind, Our Gallant Frog has already swallowed him.
He cries to the gods; she laughs at him.
He resists. She pulls. During this struggle
A Hawk, who is hovering above, looking around,
Sees the poor Rat splashing in the water:
He swoops down, gets him,
 And also the Frog
 Who is tied to his leg.
 With this double prey
The Bird's heart fills with happiness,
Getting in this way
Both meat and fish.
The best-planned strategy
Can boomerang on its planner;
And often Treachery gets back at its perpetrator.

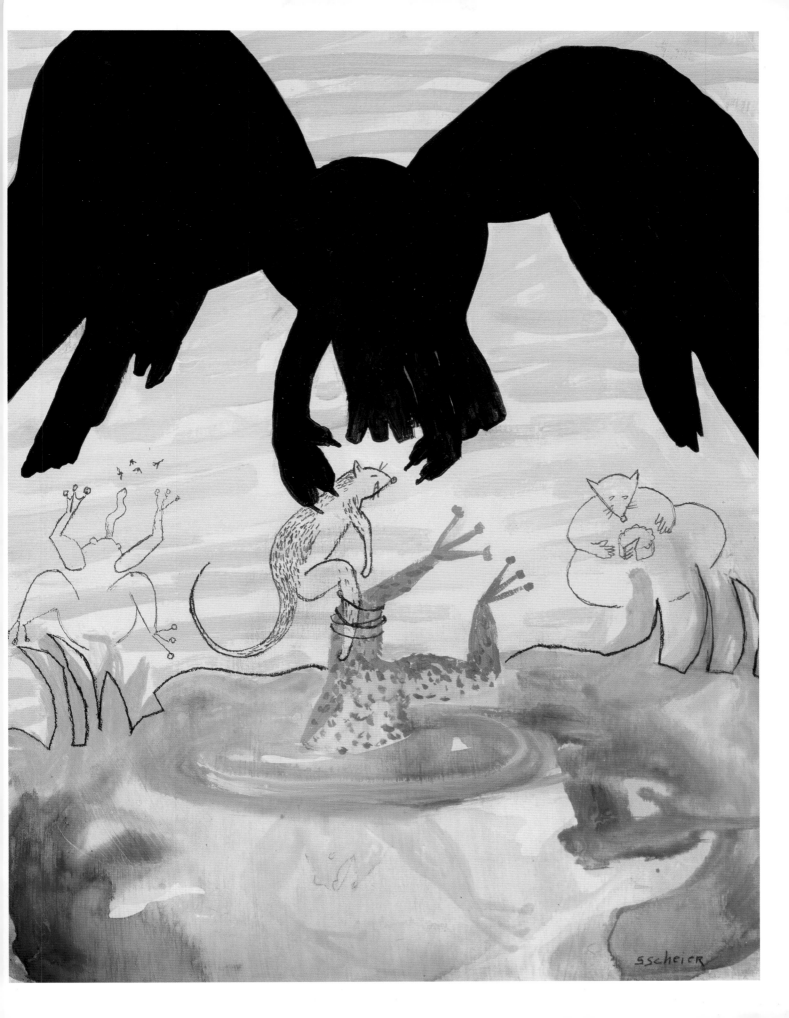

The Horse Who Wanted to Take Revenge on the Stag

BOOK IV, FABLE 13

Le Cheval s'étant voulu venger du Cerf

Jaune Quick-To-See Smith, USA

In the beginning of time, horses did not serve Man.
When Man was satisfied gathering roots,
The donkey, horse, and mule lived in the forests:
And one was not aware, as in our century,
Of so many saddles, bits,
Harnesses for battle,
So many chariots, so many carriages,
As there weren't so many
Festivals or wedding ceremonies.
Well, a horse could never catch up
With a stag running at full speed;
So the Horse resorted to Man, whose skill he sought.
Man harnessed him, got on his back,
And gave him no rest
Until the stag was hunted down.
This accomplished, the Horse thanked Man, his benefactor:
"I am at your service anytime," he said. "Good-bye.
Now I am returning to the woods."
"No, don't do that," said Man, "It's better to live among us:
I can see your usefulness.
Stay, then, and I'll treat you well, and feed you."
Alas, what use is eating well
When you have no freedom!
The Horse realized that he had done a foolish thing;
But time had run out: already his stable was built.
He died there, pulling on his reins.
Whatever pleasure comes from vengeance, the cost is too high.
When you sell out on one kind of virtue,
The other virtues are meaningless.

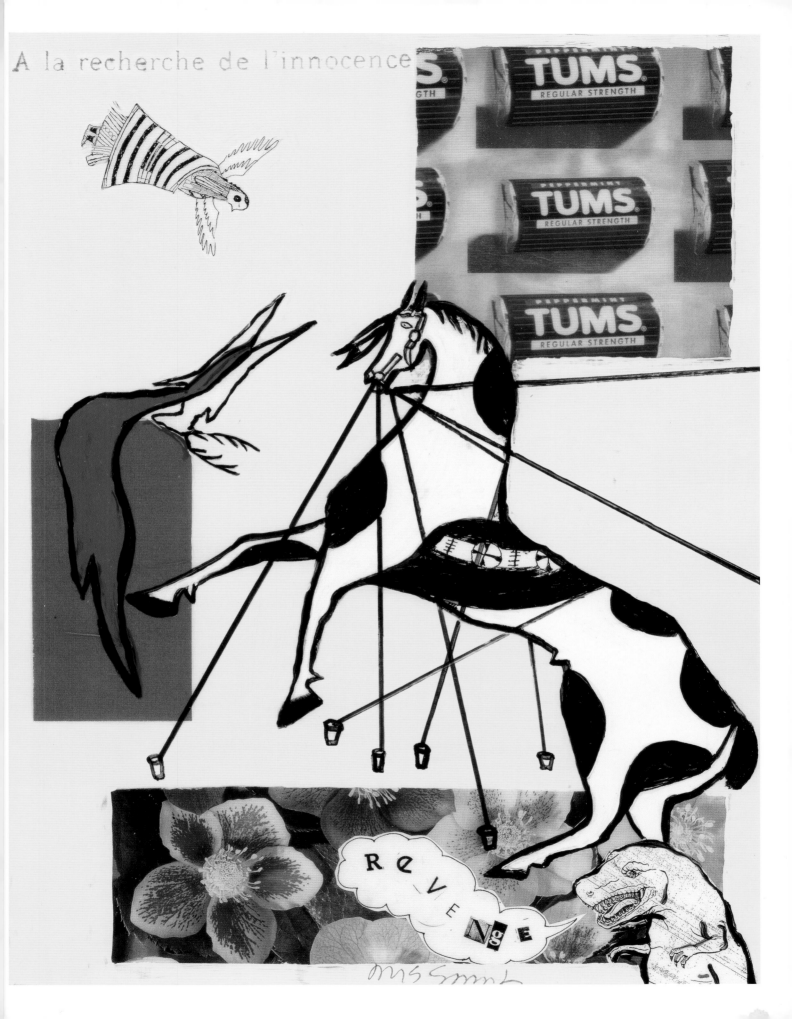

The Clay Pot and the Iron Pot

BOOK V, FABLE 2

Le Pot de terre et le Pot de fer

Norman Lundin, USA

The Iron Pot suggested
To the Clay Pot that they take
A trip. The Clay Pot declined,
Saying it would be wiser
If he tended to his hearth,
For just the slightest, slightest
Shock would be the efficient
Cause of his untoward demise:
He'd reach home, though in pieces.
"But you" he replied, "your skin
Is more durable than mine;
What's keeping you from going?"
—"I'll keep you well protected,"
Said the Iron Pot at once.
"If anything hard out there
Were to come in threatening range,
I'd place myself in the way
And you'd be ever so safe."
The Clay Pot was persuaded.
The Iron Pot, his comrade,
Then took him by the handle
And off they went on three legs,
Hobbling there as best they could,
One bouncing off the other
At the softest little bump.
The Clay Pot, racked with pain, was barely out the door
Before his hard, fast friend had shattered him to bits,
 No chance even to complain!
With other than an equal, do not cast your lot,
 For you will end up broken
 Or regretful, like that pot.

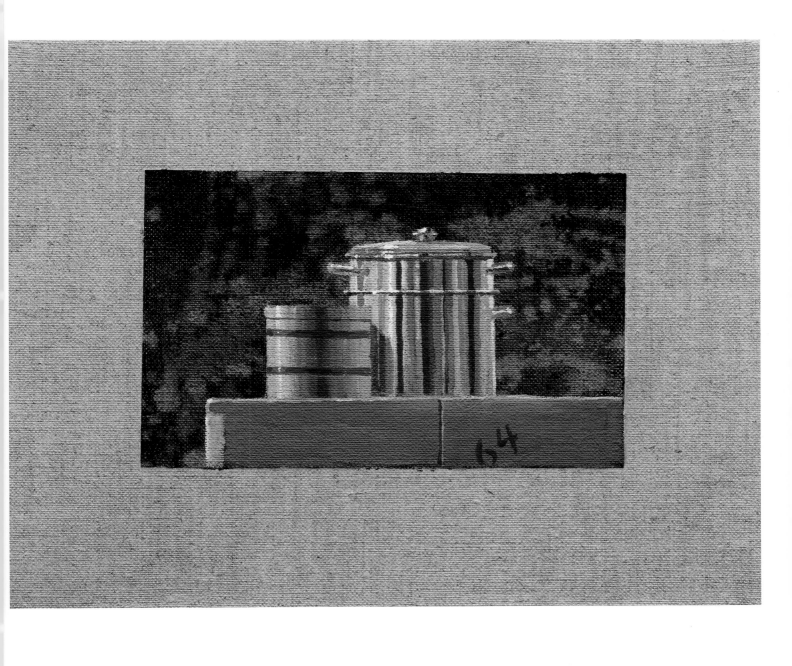

The Ears of the Hare

BOOK V, FABLE 4

Les Oreilles du Lièvre

Linda Beaumont, USA

A horned Animal, with a blow or two,
 Wounded a Lion. Furious with rage,
 The Lion swore he'd not be struck again,
 And banished from his domain
All animals with horns.
Goats, Rams, Bulls found new abodes.
Buck and Deer sought a change of climate.
A Hare, spotting the shadow of his ears,
 Trembled that some Inquisitor
Might easily mistake their length for horns.
"Goodbye, Cricket, my neighbor," said he,
 "I'm getting out of here,
Since my ears could be taken as horns;
And even were they short as an Ostrich's,
I'd still be scared to death." The Cricket answered:
 —"You call those horns? You take me for an imbecile?
 Those are God-given ears."
 —"But they'll say that they are horns,"
Said the frightened Hare, "and even horns of Unicorns.
I would have no chance protesting; anything I'd say and all my
 reasoning
 Would lead me straight to the Insane Asylum."

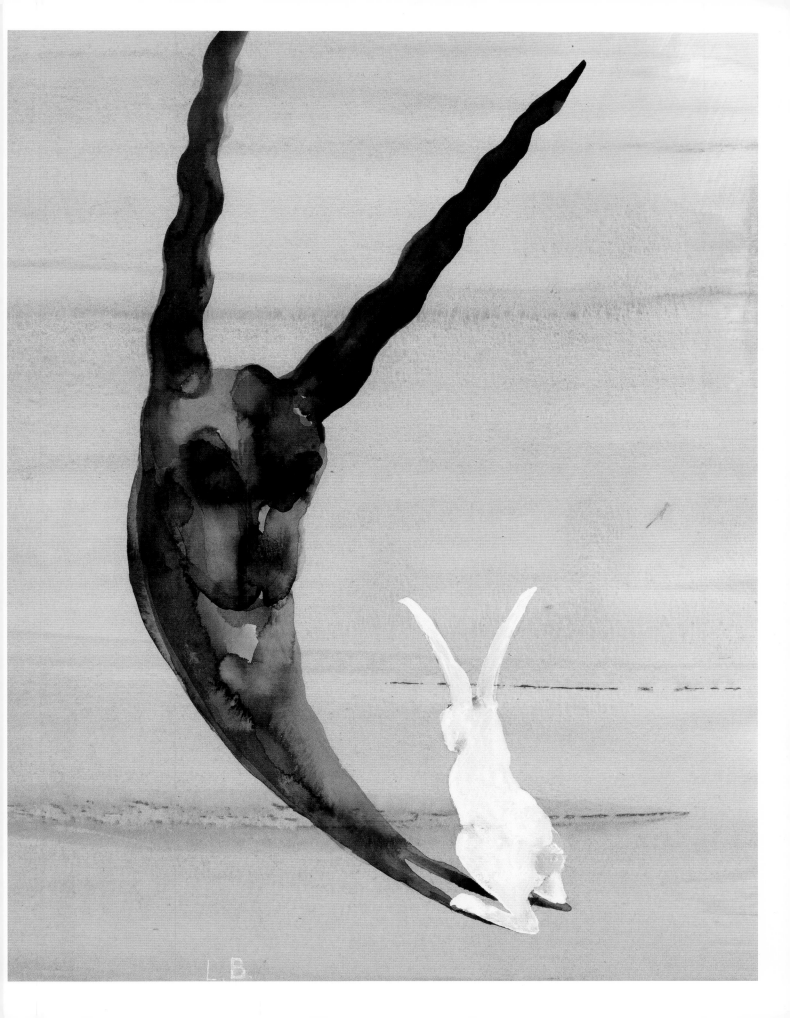

The Old Woman and the Two Servant Girls

BOOK V, FABLE 6

La Vieille et les deux Servantes

Allegra Marquart, USA

There was an Old Woman who had two Servant Girls.
They were such fine Spinners
That the Fates were nothing in comparison.
The Old Woman's primary concern
Was to assign them their tasks.
As soon as golden-haired Apollo arose,
Wheels started to turn
 And spindles to whirl, relentlessly.
No sooner had Dawn's chariot appeared
Than a miserable Cock would crow,
And the old Crone, lighting a lamp
And donning a cruddy apron,
Would run to the bed where the poor Servant Girls
 Were trying to get some sleep.
One half opened an eye, the other stretched an arm,
But both through gritted teeth muttered:
 "Cursed Cock, you shall die!"
No sooner had they cursed him than he got sick.
And Dawn's burglar had his throat slit.
Did his demise ease their lot? Hardly.
No sooner would they get to bed
Than the Old Lady, fearing lost time,
Would run around the house shouting like a preacher.
 And so it is, most often,
That when we think we are getting out of a bad deal,
 We sink deeper into trouble.
 Take the two Servant Girls as an example.
They traded the Cock for the Crone,
 And ended up between Scylla and Charybdis.

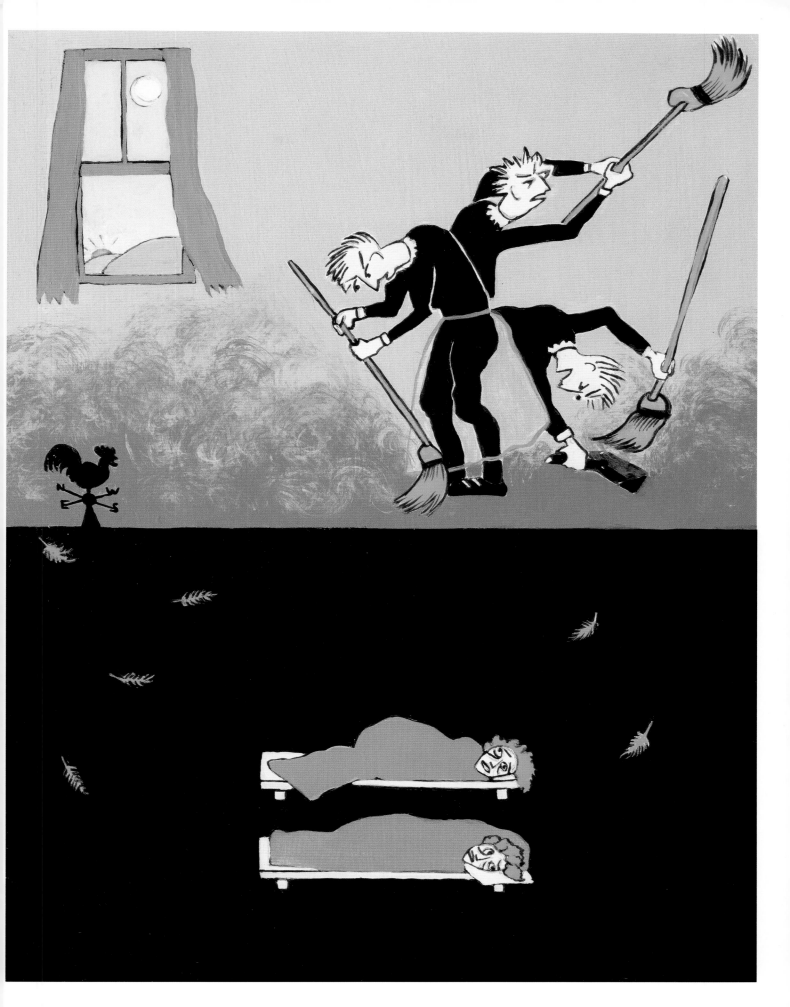

The Mountain Giving Birth

BOOK V, FABLE 10

La Montagne qui accouche

Peter Tillberg, Sweden/France

A Mountain racked with labor pains
Now roared, now bellowed for all she was worth.
Those who heard the grunts and straining
Were sure that she was giving birth
To a city twice as big as Paris.
What came out was a mouse as heiress.

And when I think about this fable
(The story open to question rather,
Although the meaning's undeniable),
I picture to myself an author
Saying, "I'll sing the war the Titans waged
Against the Master of the Thunderbolt enraged."
And I think, oh really? What usually results there?
 Just hot air.

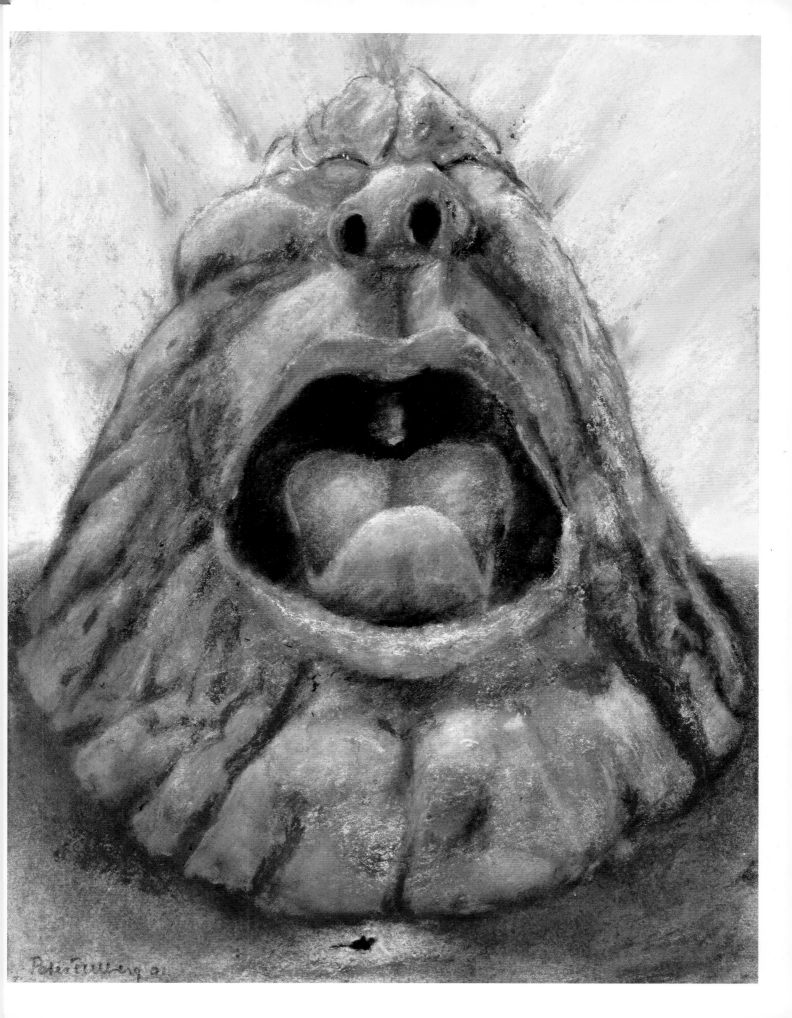

The Hare and the Tortoise

BOOK VI, FABLE 10

Le Lièvre et la Tortue

Vincent Buffile, France

It's not the speed that counts
But knowing when to start.
A Hare and a brave Tortoise
Provide the story for us.
"I'll bet," said our slow friend,
"That you won't reach the finish line
Before I do."—"Before you?
You've got to have a screw
 Loose," said the lightweight beast.
 "My Dear, I'd better lend
 You a dash of hellebore."
 "A dash or not, I want to bet."
 No sooner said than done.
 Beside the goal the stakes
 Were placed; how much? It makes
 No difference, nor even who kept score.
Our Hare had but four hops to win.
I mean the ones he makes
When, on the point of being caught, he shakes
The Dogs, and sends them for a spin.
 Having, I say, an ample time
To eat and sleep and listen to the wind,
 He lets the Tortoise hobble off,
 No quicker than a Senator with a cough.
 She's out the gate, she does her best,
 Festina lente, for the rest.
The Hare, despising easy victory,
 Makes little of the wager,
 Considers it his duty
To leave late. Now he nibbles grass,
 And now he rests; in fact,
 He clutters up his act
 With everything except the race.
But finally, when he spied
The other edging to the finish line,
He shot off with a burst
Of speed; his efforts were in vain:
The Tortoise came in first.
"So there," she cried, "I've done you in!
 What good's your speed? And how's
 That for easy victory! Just imagine
 If *you*, my friend, had had to carry a house!"

The Hound Who Left His Prey for a Shadow

BOOK VI, FABLE 17

*Le Chien qui lâche sa proie
pour l'ombre*

Gilgian Gelzer, France

Down here below, who doesn't make mistakes?
 So many Crazy Fellows
 Chase mere shadows,
 Too many for your double takes!
They're like the hound old Aesop talked about:
Along a river, in hot pursuit, quicker than you can think,
Seeing the reflected image of his prey, he jumped in the drink
And nearly drowned, swept under (save for his snout).
The waters churned to foam, and, soaked and soddy
 He barely clawed his way back up the bank,
 And didn't get the shadow, or the body.

The Charlatan

BOOK VI, FABLE 19

Le Charlatan

Ying Hung, China/USA

The world has always had its charlatans.
This science has from way back when
Been rich in fertile advocates.
Here's one now on the stage below,
He's with the river Acheron in tug of war.
And this bright city slicker here
Pretends to outshine Cicero!
A fine example of this latter breed
Was bragging of his mastered Eloquence;
That he could give fine speech to a simple passerby,
A Yokel, a big fat Boor, a sluggish Oaf:
 "Yes, ladies and gentlemen, bring me an Oaf,
 An Animal, an Ass—
 Bring me an Ass, a remedial Ass;
 I'll make of him a true past Master
 And have him don the Doctoral Gown."
The Prince caught wind of this, and, with a letter,
Summoned at once the haughty Rhetor.
"I have," said he, "down in my stables,
A splendid 'Rosamonte' from sweet Arcadia.
I'd like to make of him an Orator."
"Sire, anything you like," replied our man.
A fee is paid to him with this injunction:
 In ten years' time, without compunction,
 You'll have the Ass defend a doctorate.
 It fails? You'll be arraigned in the public square,
 Collar in the noose, strangled then and there,
 With "Rhetor" pinned to your back
 And long ears in your hair.
A courtier then graciously remarked
He'd like to go and see him at the gallows;
That, for a dangling man,
His grace and presence would be simply grand!
Provided he supply, of course,
The happy Audience with a long Discourse
Where his fine Art might swell in amplitude
And pathos; art whose formulations, never rude,
 Might serve as caution for that troop of Ciceros
 Commonly known as thieving Joes.
 Our Rhetor then replied, "Before that happens
 The King, the Ass, or I'll be dead."
 And he was right. Folly it is instead
 To count on ten long years of life.
 Eat, my friends, and drink, and do be merry,
 And in ten years we'll see who death will harry.

The Animals Sick from the Plague

BOOK VII, FABLE 1

Les Animaux malades de la peste

Elin O'Hara Slavick, USA

A terrible ill that
 Heaven in its fury
Invented to punish crimes on earth,
The Plague (since we must call it by its name)
Capable of enriching Acheron, in just a day,
 Declared war on the animals.
They didn't all succumb, but all were affected;
 None of them had the energy to live,
 And there was no food that tempted them;
Neither Wolf nor Fox went after
Sweet and innocent prey;
The Doves were apathetic,
No longer loving, no longer joyful.
The Lion called a council and said: "My dear friends,
 I believe that heaven permitted
 This misfortune because of our sins;
 May the guiltiest one among us
Sacrifice himself to appease the celestial anger;
Maybe in this way everybody's health might be restored.
History teaches us that in similar circumstances
 One must show similar selflessness.
Let us not kid ourselves, and let us without illusions
 Examine the state of our conscience.
Speaking for myself, in satisfying my gluttony
 I have devoured more than one sheep;
 What had they done to me? Nothing;
And sometimes I even ate their shepherd.
I will therefore sacrifice myself, if I have to, but
I think it may be a good idea if each one of us comes clean,
like me,
Because in all fairness, it's the guiltiest among us
 Who must die."
"Sire," said the Fox, "you are too good a King;
Your scruples show your sensitivity.
Well, eating sheep, those worthless and dumb creatures,
Do you call that a sin? Certainly not. In croaking them, Sir,
 You actually honored them.

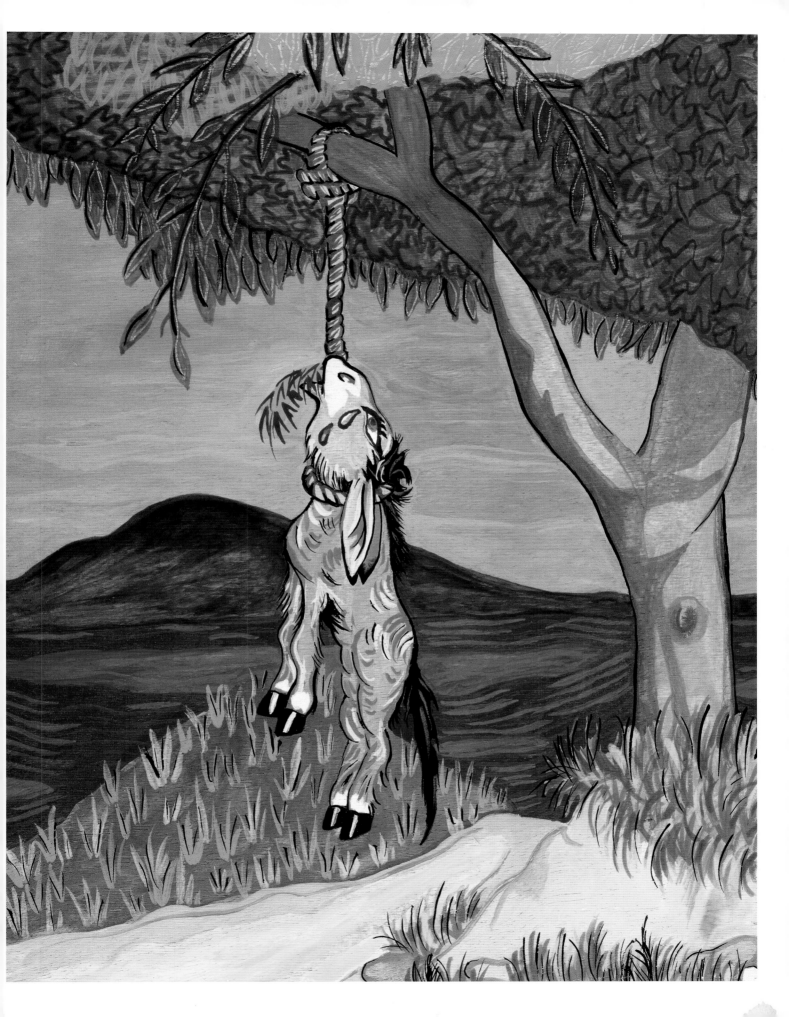

As for the shepherd, one must admit that
He deserved what he got,
Since he is part of that gang that builds imaginary
Empires on the backs of animals."
Thus spoke the Fox, and the flatterers applauded.
They didn't dare get into the grossest offenses
Of Tigers, Bears, or other powers.
All quarrelsome ones down to the simplest sparrow
Turned out to be little saints, according to testimony.
Then came the Donkey's turn. He said,
"I remember crossing a field that belonged to the Monks,
And hunger, the opportunity, the appetizing grass . . .
I don't know what demon possessed me
To snatch a patch of grass the length of my tongue.
I know I didn't have the right, but since we are all leveling with
each other . . ."
When they heard these words, the other animals
Shouted indignation at the stupid Ass.
A Wolf who had some legal knowledge proved in presenting
His argument that the cursed animal had to be devoured.
This ignoramus, this criminal.
His infraction was judged as deserving capital punishment by
hanging.
Eating somebody else's grass! What a heinous crime—
Death could be the sole expiation! And that's what they did.
According to whether you are powerful or poor,
The Court's judgments will prove you guilty or innocent, black
or white.

The Poorly Married Man

BOOK VII, FABLE 2

Le mal Marié

Christine Martens, USA

May the good always be the companion of the beautiful.
 Starting tomorrow, I'll start looking for a wife;
But the separation between the good and the beautiful is
 nothing new,
And few beautiful bodies, hosting a beautiful soul,
 Have the other attribute too.
Don't think it strange that I haven't looked.
I've seen many unions; none of them has impressed me:
Nonetheless, four-fifths of humanity
Boldly expose themselves to this greatest of dangers.
I will mention one, who, having been sorry,
 Was able to find no another solution
 Than to send his wife away,
She who was quarrelsome, stingy, and jealous.
Nothing pleased her, nothing was done right;
The servants were furious, the husband reached his limits;
Monsieur is thoughtless, Monsieur is a spendthrift;
 Monsieur runs around, Monsieur is lazy.
She said so many things that in the end, Monsieur,
 Sick of listening to such tirades
 Sent her to the country
To her parents. So there she was in company
With country girls who were looking after the turkeys
 And their guardians the pigs.
After some time she seemed to soften
And the husband took her back: "So what did you do?
 How did you spend your time?
Is the innocence of the countryside your thing?"
"Enough!" said she, "My annoyance was
To see people there lazier than those who are here;
 They really didn't care about their flocks
And I told them so and brought the hatred
 Of those careless people on me."
"Well, Madame," responded the husband,
"If your spirit is so irritable
 That those who spend
A moment with you and don't return until evening

Are sick of seeing you,
What are the servants expected to do
 Who must see you all day after you set after them?
 And what can your poor husband do
Whom you expect to spend night and day with you?
Go back to your village. Good-bye! If ever I call you back
 Or feel like seeing you,
May I in the kingdom of the dead have
As my atonement for my sins
Two women like you incessantly by my side."

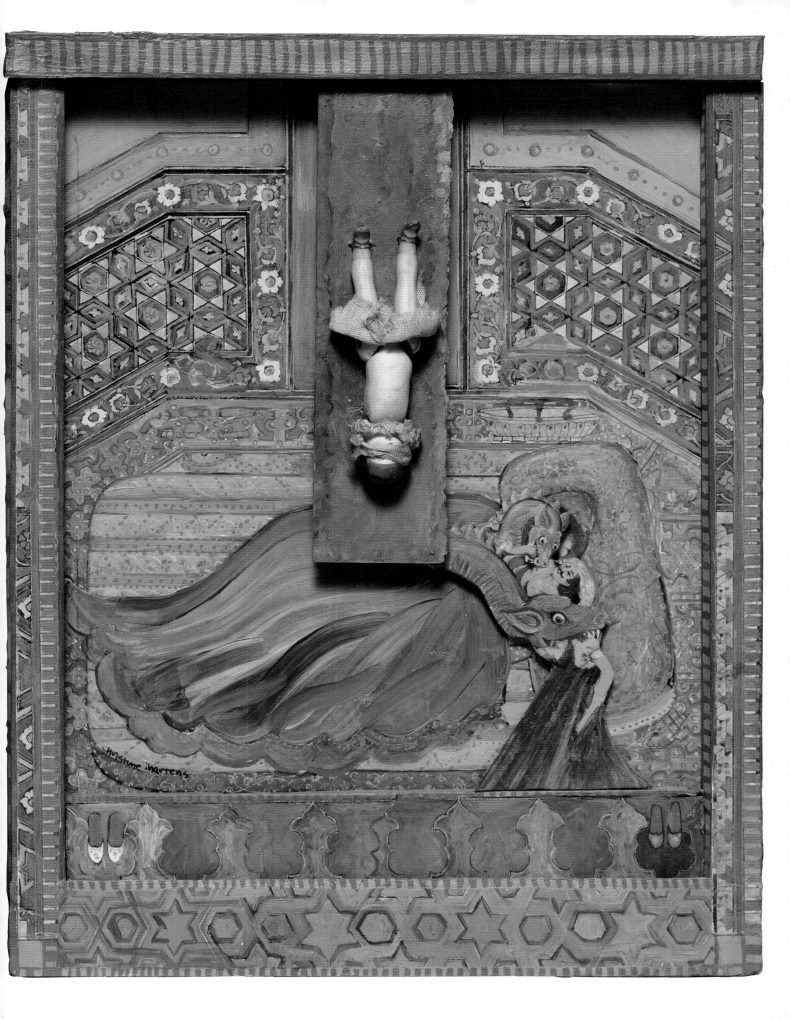

The Rat Who Retired from the World

BOOK VII, FABLE 3

Le Rat qui s'est retiré du monde

Andrew Johnson, USA

There was a Levantine tale
About a Rat who, tired of it all,
 Hid in a Holland Cheese,
 A true soundproof shelter.
This modern Hermit found a way to use
 Both claws and teeth—
It took a few days only to create
Both a den and a source of food,
So that he became plump, even fat; God looks after his own,
 Those who take the vow of obedience.
 One day some Rodents
Came to our convent to ask for a modest donation;
 They had gone everywhere
To raise funds against the feline race;
 As Ratopolis was blockaded,
They were forced to leave penniless,
 Given the economic situation
 Of the beleaguered Republic.
They weren't asking for much, convinced that the siege
 Would be lifted in a few days.
 "My friends," said the Hermit,
"The things of the world do not concern me,
 And pray tell me
 How could a poor Recluse help you?
He is powerless except through prayer, beseeching Heaven
Not to abandon you and to bring you aid."
 Having spoken thus
 The Modern Saint slammed his door.
 Tell me, in your view, who is it I'm singling out
 Via this unaccommodating Rat?
 A Monk? No, a Dervish.
I imagine that a Monk always practices generosity.

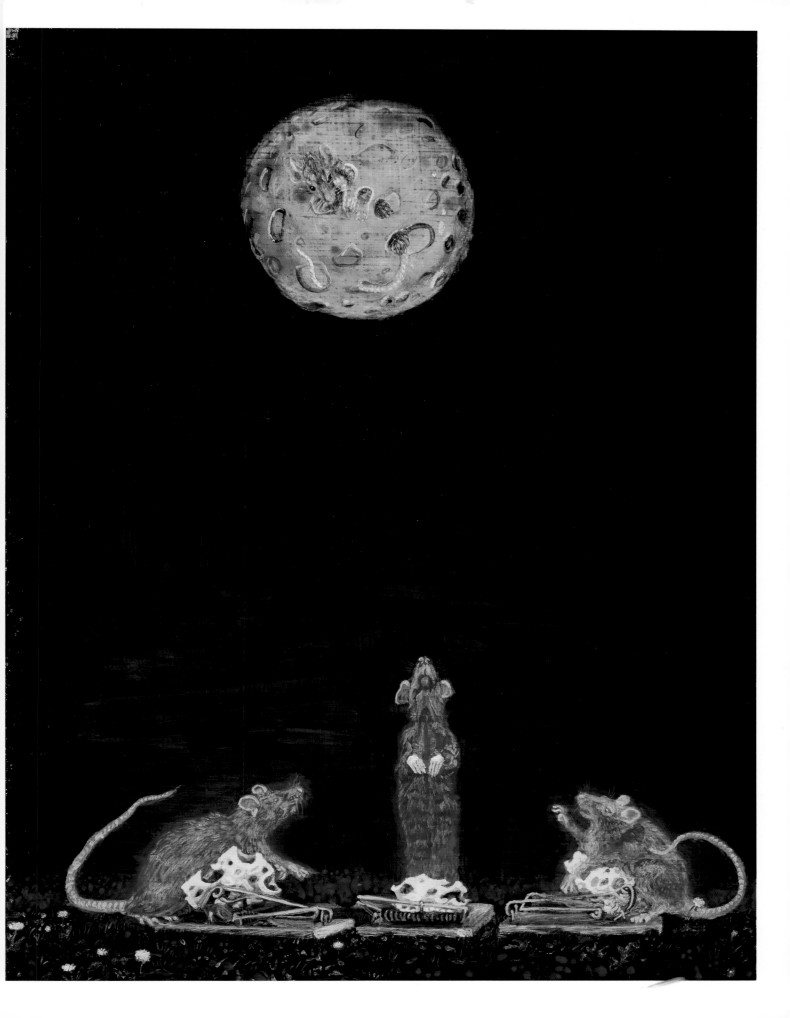

The Milkmaid and the Pot of Milk

BOOK VII, FABLE 9

La Laitière et le pot au lait

Sarah Slavick, USA

Perette had the Pot of Milk well-positioned
 On a pot-holder on her head,
To move with greater ease toward the town.
She wore a short dress, took long strides on flat-heeled shoes.
 Thus made-up, our Milkmaid already,
 In her mind, was counting her profit
 And how she would spend it,
Such as buying a hundred eggs,
The chickens would lay three times a day,
 Business would thrive.
"But with crafty Foxes around, is it wise to raise chickens?
 Maybe it would cost less to raise a pig
 And sell it when it got fat.
And with the money I could afford a cow and her calf
 Prancing around our shed."
She got so excited at the thought that she leapt up.
The Milk fell: good-bye calf, cow, pig, servile hens.
The Lady looks with a repentant eye, all this wealth scattered away,
 And goes to find her husband,
 Sheepishly, hoping to avoid a beating.
 And thus was born
 The tale of the Pot of Milk.

 All dreamers like to build castles in Spain,
From Antiquity to our Milkmaid, wise and foolish dreamers both.
 All of us at some point imagine the world to be ours,
 All honors and all women belong to us.
Even I have illusions sometimes, vanquishing enemies,
 Being a much-beloved King, diadems on my head.
What mishap would it take to bring me back
 To the hard reality of the boor that I am.

The Cat, the Weasel, and the Little Rabbit

BOOK VII, FABLE 15

Le Chat, la Belette, et le petit Lapin

Nathaniel Vaughn, USA

Dame Weasel one fine morning stormed the palace
　　Of young John Rabbit. Tricky she was indeed!
Taking over his house with crafty malice,
And setting up all her household gods
When he had gone to pay court to the Dawn
　　Among the sprigs of thyme, the drops of dew.
Having grazed and hopped his gentle rounds,
John Rabbit sought his underground abode
To find the Weasel sitting at the window.
"O gods of sacred hospitality!
　　What means this innuendo?"
Cried the animal, evicted from his father's home.
　　"Hey ho! O Mistress Weasel,
　　Let's get a move on, quiet like,
Or every rat of the realm will hear of it."
The Lady with the pointed nose replied
　　That land belonged to whosoever got there first.
　　A pretty subject for dispute,
This hole where even he
Must squeeze and crawl to enter!
　　"And if it were a kingdom,
I'd really like to know," said she,
　　"What law would grant it for all time
To John, Pete's son or nephew, or to Bill,
　　And not to Paul, or me!"
John Rabbit rattled off the code and custom:
"It is," he said, "their laws that make me
Lord and master of this abode, and which,
From father to son, i.e., from Pete to Simon,
Have duly been transmitted."
"First Occupant, is that a wiser law?
　　Well then, without much more ado, let us
Refer the case," she said, "to Raminagrobis."
This was a Cat, a hermit, and indeed devout,
　　A Cat who practiced *kittysweet*,
A holy man of a cat, well dressed in fur,
As sleek as he was fat, an arbitrator

Par excellence fit for any situation.
John Rabbit authorizes him as judge.
So now the two arrive
Before His Majesty in fur.
Grippeminaud (his other name) then purred,
"My children, please come closer, do come near.
Old age has made me deaf."
Closer then, without the slightest fear,
Our two disputants come in range,
When Grippeminaud, the perfect saint,
Letting fly his two claws right and left,
Ends the litigants' dispute with one big bite.
This story is the sort of thing
That happens sometimes to the little lords
Who take their quarrels to the King.

Death and the Dying Man

BOOK VIII, FABLE 1

La Mort et le Mourant

Ellen Kruger, Germany/USA

Death doesn't take the wise man by surprise:
 For having come to terms about the trip
 We must resolve to take one day,
He is at all times ready to depart.
Alas, that moment comprehends them all!
Divide it how you like: days, hours, or seconds;
 No increment of time can fail to share
In Nature's fatal tribute. All succumb;
The happy hour where children of kings
 In tender light open their eyes,
 Will sometimes be the one that seals
 Their eyelids for eternity.
 Protect yourself with majesty,
Or bow to beauty, virtue, youth—
 Indecent death will take it all away.
The world itself will end up as its prize.
 And though as common as our breath,
 I have to say that death
 Is what we all are least prepared for.

A hundred-year-old man who was about
To die, sat bickering with Death. Incredible
That she had come without the slightest warning,
 Obliging him to pack his bags
 Before he'd made his will and testament!
"Where's justice," said the man, "if one must die
At a moment's notice? Come and get me later.
My wife will never let me go without her;
I must arrange a marriage for my grandson;
Pray let me add another wing to the Château.
O Cruel Goddess, why all this rush to go!"
"Old Man," said Death, "I'm no surprise for you.
You've got no reason to complain.
Aren't you a hundred? See if you can find
In Paris two as old as you, or ten
In all of France. You say I should have given
 Warning so as to make things easier:

I would have found your testament complete,
Your grandson and the Château taken care of.
But wasn't it sufficient warning when
 You finally couldn't walk or move about,
 When thoughts and feelings failed you? For the rest,
You're deaf and cannot even taste your food;
In vain, the day star sheds its light on you.
Why weep and sigh for pleasures that are through?
 I've shown you all your friends,
 Some dead, some nearly dead, some sick.
What's all of this, if not a warning?
 Let's go, old man. Don't answer back.
 For the Republic doesn't give a whack
 About your testament . . . not in the least."
And Death was right. I think that men his age
Should say goodbye like one who leaves a feast,
Thanking the host, with bags already packed;
For just how long can one delay departure?
You're mumbling, old man; see these soldiers, young
 And dying. See them marching, some are running off
To die deaths glorious and sweet,
But sure in any case, and sometimes cruel.
In vain I tell you—pardon my zeal—
The ones who most resemble death
Are those Death has to drag off by the heel.

The Man and the Flea

BOOK VIII, FABLE 5

L'Homme et la Puce

David Humphrey, USA

The gods find our inopportune requests tiresome,
Often about things that even humans find unworthy.
People expect the Heavens to constantly keep an eye on us,
And the least of our mortal race
With every step, every triviality,
Expects the Olympian Host to intervene
As if it were a question of Greeks and Trojans.
A Flea stung an Idiot on his shoulder
And then hid in his sheets.
"Hercules!" the man cried out. "You should have purged
The earth of this Hydra now that Spring has come.
And you, Jupiter! From on high in the firmament
You do nothing to avenge me?"
To kill a flea, he wanted to get
Those gods to use thunder and club.

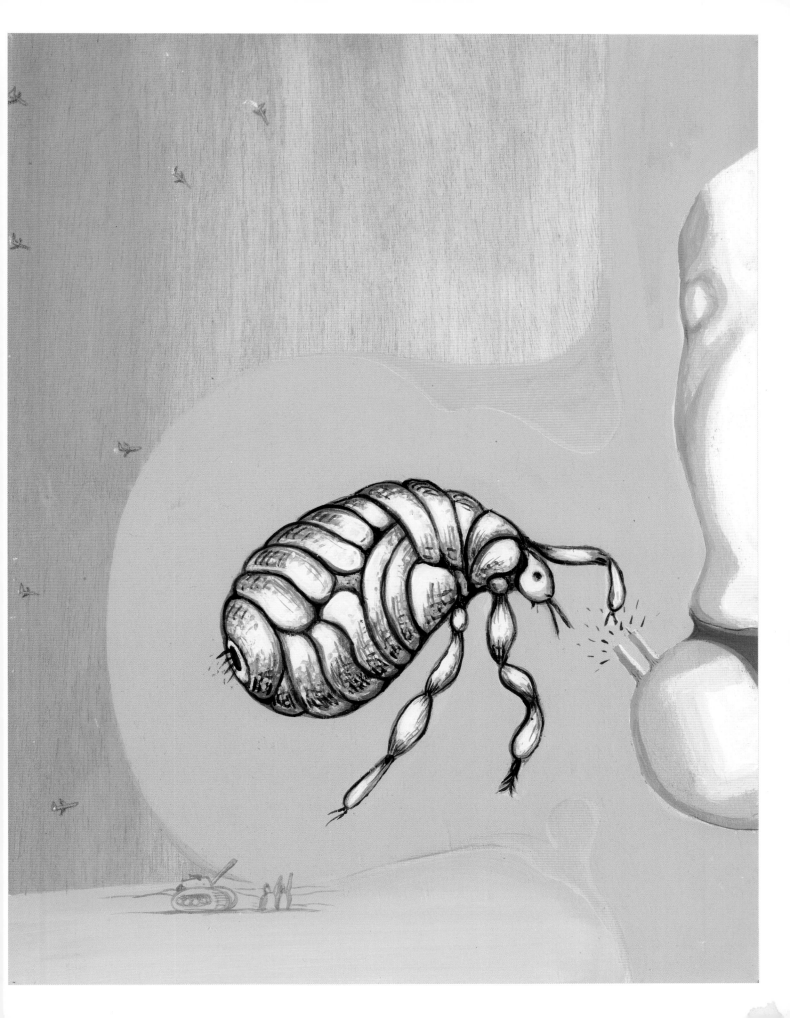

Women and the Secret

BOOK VIII, FABLE 6

Les Femmes et le secret

Ruth Marten, USA

Nothing weighs so heavily as a secret;
Women can hardly contain secrets, and
 Many men, as well, I must admit.
To test his wife, a man one night,
 Lying next to her, cried out:
"Oh God! What is this? I can't stand it anymore;
 I'm being torn apart. Wow! I'm giving birth
To an egg! An egg? Yes, fresh as day:
Be sure not to spread the news, or I'll be called a hen.
 In any case, tell no one."
 All this was new to the inexperienced wife.
She believed her husband, and swore to the gods
 Not to utter a word.
 But this promise faded away,
 Along with the shadows of the night.
The indiscreet and not well-educated wife
Gets out of bed as soon as it is light:
 And runs to her neighbor.
"Godmother," she says, "an amazing thing happened:
Keep it to yourself or else my husband will beat me up.
 My husband just gave birth to an egg, four times
The normal size! For God's sake be careful
 Not to broadcast this miracle."
"Count on me. You know me. Have no fear."
The wife of the egghatcher goes back to her house.
The other is itching to blab the news.
She embroiders. Instead of a single egg,
 She says three.
And that's not all, for another gossip whispers that it's four.
She needn't have whispered,
As the news was all over the place.
And as the number of eggs kept increasing
In this mouth-to-mouth game,
At the end of the day, the number had become a hundred.

The Pig, the Goat, and the Sheep

BOOK VIII, FABLE 12

Le Cochon, la Chèvre, et le Mouton

Constantine Christofides, USA/France

A Goat, a Sheep, and a fat Pig
Were headed for the fair, riding on the same cart.
It wasn't a happy moment, as they were going to be sold,
According to the story.
 The Charioteer wasn't exactly going
 To take them to a fun show:
 Mr. Piglet was squealing all the way
As if he had a hundred Butchers after him,
Causing a deafening racket.
The other animals, who were gentler, were amazed that
 He was crying out for help,
As they didn't think there was anything to be afraid of.
The Charioteer said to the Pig: "What's the matter with you,
Complaining and distracting us instead of keeping quiet like
These other two lovers of life?
They could teach you how to live well, or at least to hold your
 tongue.
Look at this Sheep. Did he utter a single word?
 He is so wise."—"He is stupid!"
Retorted the Pig. "If he knew what was going on,
He would be yelling,
 And this other nice creature
 Would be screaming her head off.
They think that all anyone wants is to relieve the Goat
 of her milk,
And the Sheep of its wool.
 I don't know if they are right or wrong,
 But as for myself,
 Who only thinks of eating, my death seems certain.
 Adieu, my hearth and my house."
It was pretty subtle reasoning on the part of the Pig.
But what use was it? When evil is rampant,
Neither complaints nor fear can change anything.
It may be more stoical not to anticipate the worst.

The Horoscope

BOOK VIII, FABLE 16

L'Horoscope

Caren Canier, USA

You meet up with your destiny
Often through the ways you took to avoid it.
 A father had as only descendant
A son whom he loved too much, to the extent of
 Consulting soothsayers
 On the fate of his offspring.
One of them told him that until a certain age,
He should especially keep the boy away from lions:
 Until the age of twenty, no more.
 The father, to observe this
Precaution on which depended the life
Of the one he loved, forbade him ever
To cross the threshold of his palace.
He was allowed without going out to satisfy his urges;
With his companions
 To jump, run, promenade all day long.
 When he came of an age when hunting
 Appeals to the young,
 This sort of thing was described to him with scorn:
 But whatever the counsel, the teaching, the argument,
 One can't change human temperament.
The young man, anxious, passionate, courageous,
Had hardly reached the age when the young
 Yearn for pleasure.
He knew the subject and its fatal possibilities;
Oh, this palace full of magnificent things,
 Covered with paintings:
Canvas and brush
Depicted hunts and landscapes all over the place.
 Here you could see animals, there humans,
So that the young man was moved when he saw a lion.
"Monster!" he cried. "It's you who makes me live
In the dark, shackled up!" With these words
He threw a fit of indignation,
 Brought his fist upon the poor animal
On the tapestry and hit a nail underneath.
 This nail wounded him. It hurt him seriously,
And there was nothing Asklepios could do for the poor boy,
Who perished through the care he was given in order to be saved.
The same precaution happened to the poet, Aeschylus.
 Some seer threatened him, it is said,
 With the collapse of a house.
 He rushed to leave the city
And placed his bed in the middle of a field,

Away from rooftops, under the skies.
An Eagle who was carrying a Turtle in the air
Happened to fly overhead, saw the man, and on his bald head,
Which looked like a rock, he dropped his prey
 In order to break it up:
Poor Aeschylus thus ended his days.
 From the above examples,
 It can be demonstrated that
This art of divination, if there be any truth to it,
 Causes harm to whoever consults it;
I can't justify it, and maintain that it is false.
 I don't believe that nature
Either ties its hands, or ours,
To the point that the heavens can regulate our fate.
 It depends on conjecture,
 Or place, time, people;
Not on the planetary conjunctions of these charlatans.
Shepherds and Kings are under the same planet;
One carries a scepter and the other a crook:
 That's what Jupiter wanted.
Who is Jupiter? A body without knowledge.
 How come, then, his influence
Has a different effect on these two men?
How does one penetrate country air,
Pierce Mars, the Sun, endless space?
An atom can alter this influence:
So where can the makers of horoscopes
 Predict the state that Europe is in?
Did any one of them predict it?
If so, he didn't say anything, but none of them knows.
Those immense distances, those points and speed in space,
 Those also of our feelings,
 Do they make it possible
To follow each one of our actions?
Our fate, in its uninterrupted path, never follows
Any more than we the same pace;
 And these people want, with their compasses,
 To trace the course of your entire life!
 We should never succumb
To the ambitious facts that I have just described.
This beloved son and good Aeschylus
Could not have altered anything. But blind and
Deceitful as this art may be,
It can strike one time in a thousand:
 That's the effect of chance.

The Pasha and the Merchant

BOOK VIII, FABLE 18

Le Bassa et le Marchand

Harvey Breverman, USA

A Greek Merchant in a certain country
Was doing business. A Pasha was his patron;
And the Greek rewarded the Pasha
In pasha style, not in merchant style: such are
The costly needs of a protector.
So when the Greek went about complaining,
Three Turks of lesser rank and power
Offered him their support in unison.
For the three of them, they wanted less reward
Than it would cost the Merchant for one.
The Greek listened and signed on.
The Pasha, of course, learned about this
And even was advised that, if he were smart,
He should deal nastily with them,
Should dispatch them with a message
Straight to Mohamed in his paradise, without delay:
Otherwise these three, united, might thwart him,
Even though there would be other people to avenge him.
He would send these men to the other world—poisoned.
In this matter the Turk performed like Alexander,
And in full confidence went to see the Merchant straightaway.
He sat down with full assurance at the table,
And in his words and comportment no one could suspect a thing.
"Friend," he said, "I know that you are thinking of leaving me;
Even though some people are afraid of what will follow.
But I believe you are a good man;
You are not the sneaky type. I won't say anything more.
As for the people who are thinking of supporting you,
Listen to me. Without giving you a big speech
Or arguments that would bore you,
I just want to tell you a story:
There was a Shepherd, content with his Dog and his flock.
Someone asked him what he expected to do with
A Big Dog whose usual fare was a whole loaf of bread.
He must give this animal to the Lord of the village
And he, the Shepherd, for economy's sake, should pick up three
 stray dogs,

Who would cost him much less to guard his flock
Than the Big Dog who ate more than three,
But who, when the Wolves came, certainly
 Didn't have three sets of teeth.
The shepherd gave in. And even though he spent less,
The dogs would run away from trouble.
The flock sensed this, just as you yourself would discover this
And run to me." The Greek believed him.
This shows that, in various regions, it's better in good faith
To accept the protection of some powerful King
Than to depend on several little Princes.

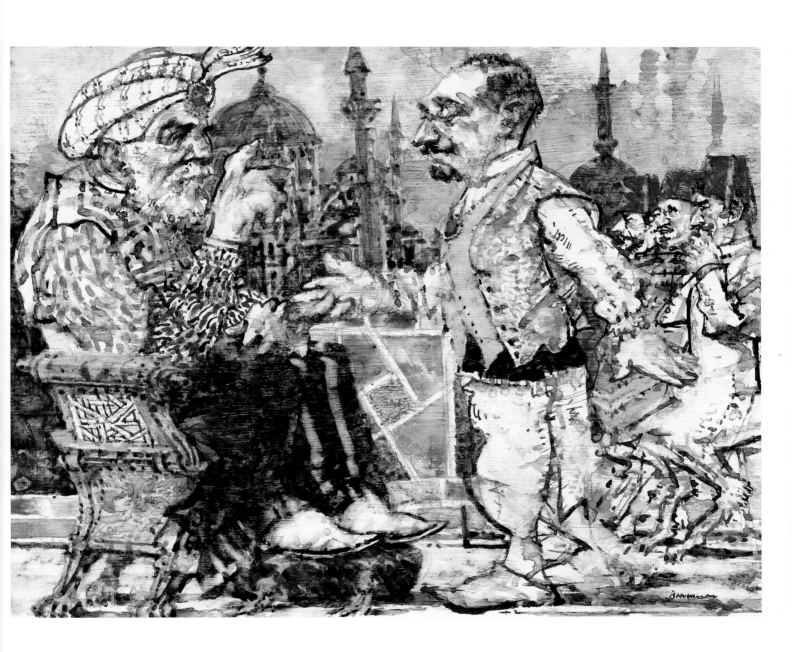

The Advantage of Knowledge

BOOK VIII, FABLE 19

L'Avantage de la science

Tim Sale, USA

Between two Bourgeois of a certain town
A disagreement arose—
The one, poor but smart,
The other, rich but ignorant.
The latter wanted to outsmart the other:
He was claiming that every wise man
Should honor him.
Was it silly to revere things that had no merit?
No reason to do that.
"My friend," he often said
To the smart one,
"You think you are somebody,
But tell me, when exactly do you give dinner parties?
What use is it to people like you to be constantly reading?
In your attic where you live,
In June you still wear your winter clothes,
And your only servant is your shadow.
 The State has no use
 For people who are not spenders:
 The only valid people
Are those whose expenditures spread the wealth around.
We use our wealth, God knows. Our needs keep busy
The artisan, the vendor, the tailor,
And all the people who buy from them, and you, who dedicate
 To Great Financiers
 Your bad books (which nevertheless are paid for)."
 These impertinent words
 Were received as they should have been.
The man of letters said nothing; he had too much to say.
War was a better avenger than his satiric words—
Mars destroyed the place where they lived.
 They both left town:
 The ignorant one became homeless—
 He was despised by everyone;
The other found his way everywhere.
 And thus, their disagreement was settled.
Let the stupid babble; knowledge has value.

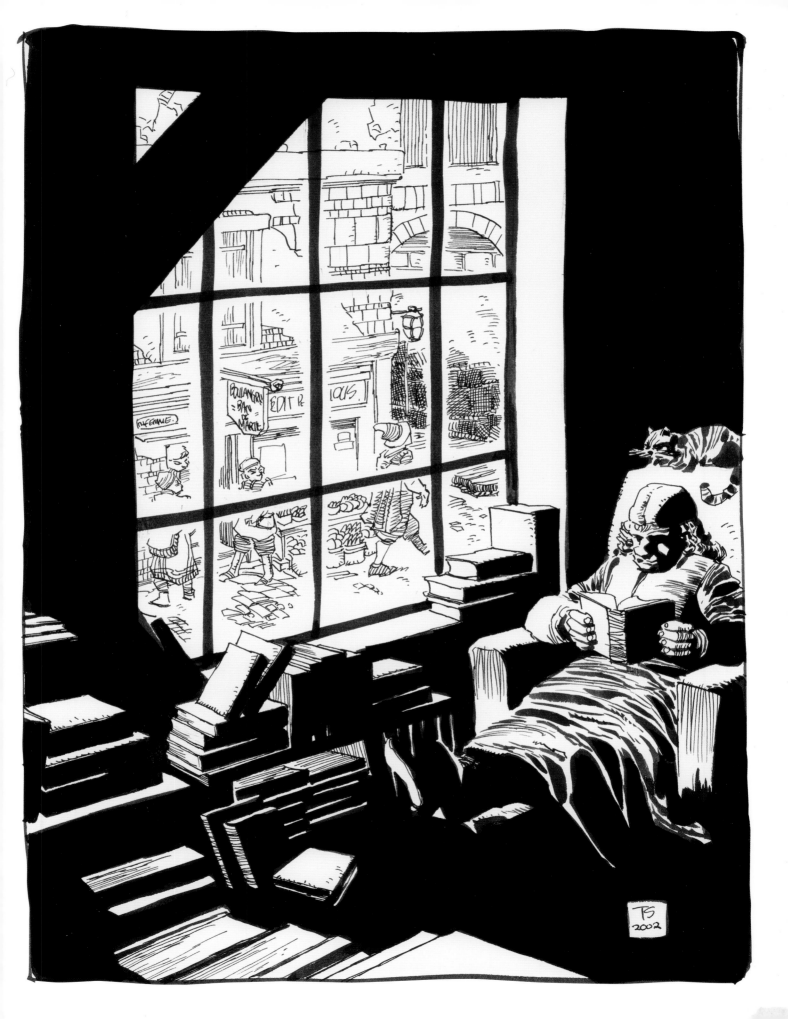

The Wolf and the Hunter

BOOK VIII, FABLE 27

Le Loup et le Chasseur

Anne Rochette, France

What monster is man, who is a maniacal consumer
And for whom the goodness of God is insignificant.
Will I oppose you ceaselessly and in vain in my work?
How much time do you need to learn my lessons?
Man, deaf to my words and deaf to the words of wisdom,
Will he ever say: "It's enough; let's just enjoy life"?
You'd better not delay, my friend, as life is very short.
I keep using this expression; one could write a book.
Enjoy.—I'll do it.—But when?—Starting tomorrow.
—Well, my friend, death could overtake you.
Start enjoying life—start today: You should always fear death.
Let me tell you the fable of the Hunter and the Wolf.

The first kills a deer with a single arrow.
A Fawn happens by, soon to join the deer's fate, both downed
 on the grass.
It was a clean kill, a Deer and a Fawn;
If only the Hunter had been satisfied.
In the meantime a Wild Boar, enormous and magnificent,
Tempts our Archer, who hasn't had enough.
Another inhabitant of the Underworld—a Fury with her
 dull scissors;
—This infernal goddess, after many tries helps knock out
 the animal.
Was this sufficient prey? Don't believe it, as nothing satisfies
The endless appetite of conquerors.
As the Pork comes to, the Archer sees a Partridge walking along
 a furrow,
Puny and miserable compared with the other bounty.
Yet with his bow he strains the drawstring.
The Boar, summoning what life is left in him,
Comes at the Archer, takes him apart, and has his vengeance
 By dying on his body.
 The Partridge offers thanks.

This part of the tale was addressed to the insatiable one:
The rest of the story is addressed to the miser.

A passing Wolf witnesses this sorry spectacle.
"O Good Fortune!" says he. "I'll build you a temple.
Four bodies stretched out? What booty! But I should be
 parsimonious,
 As such finds are rare." (This is how misers think).
"I'll have enough food," says the Wolf, "for a month.
One, two, three, four bodies, for the four weeks,
 A month if my arithmetic is right.
Let's start in two days; but in the meantime let's eat
The string of the bow; it must be made of pure gut;
If I can judge by the smell."
Speaking thus, he bites on the string, unleashing the arrow
Causing yet another death. The Wolf has his own guts pierced.

Now, to return to my text: We can take pleasure from
The tale of two gluttons who gained the same fate:
 Covetousness caused the death of one;
 Avarice, the other.

The Monkey and the Leopard

BOOK IX, FABLE 3

Le Singe et le Léopard

Michaëla-Andréa Schatt, France

Monkey worked with Leopard
Making money at the fair,
Each vaunting his own wares.
One day, the second of the two declaimed:
"Gentlemen, my talent and my fame
Are known in highest places;
The king himself has asked to see my stuff;
 And if I die, he wants a muff
Made from my skin. He's seen its graces,
 Many-hued, sumptuously spotted,
 Inlaid and iridescent, even speckled."
Oh, the lure of the pied and gaudy;
All saw the Leopard, everybody.
But soon the show was over, all were gone.
The Monkey then, whose turn it was, began:
"Approach, I beg of you, approach;
Dear Gentlemen, I know a hundred tricks.
As for the endless talk about variety,
This Leopard here can only claim to wear it.
I have it in my wits: I, Gille, your humble servant,
 Cousin and son-in-law of Bertrand
 (The Pope's pet monkey while he was alive),
Have just arrived, with three brave ships,
In this fair city with the sole desire
To speak with you; I speak, and you will hear;
Not only can I dance, and jig, and stoop
 To every sort of trick,
But can astound you with the hula-hoop;
And all this for a mere two cents!
No, not two cents, my friends, but one,
And if you're not content,
You'll get a refund at the door!"
The Monkey here was right.

Variety, the kind that titillates the sight,
Is not as pleasing as the mind
In all its endless acrobatic flair.
How many rich and powerful, like Leopard,
　　Have talent only for the things they wear!

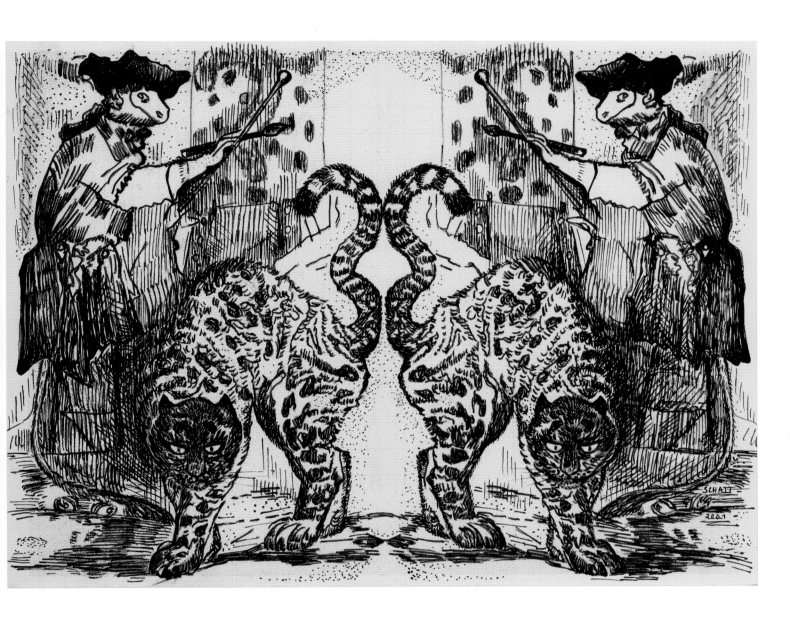

The Sculptor and the Statue of Jupiter

BOOK IX, FABLE 6

Le Statuaire et la statue de Jupiter

Ken Tisa, USA/France

There was a block of marble so exquisite
A sculptor did his best to purchase it.
"What'll my chisel make?—Let's think—
A god, a table, or a kitchen sink . . .

It shall be a god: and in his hand
I'll even add a thunderbolt.
Tremble, humans! Get down and pray.
Behold the master of the land!"

The craftsman chipped and didn't err.
He brought the idol's character
Within perfection's reach—
All the god now lacked was speech.

Word has it that upon completion,
—His image freshly polished—
The Sculptor was the first to quake
And dread his own production.

Old Homer was an early case
Of this inspired grimace,
Fearing the wrath and hatred
Of the gods he had created.

In this respect he was a child:
For children cry, their souls gone wild
With a relentless care
Lest someone vex their teddy bear.

The heart will always imitate the mind:
And from this source has sprung
That widespread error of the pagan kind,
Hither and thither on the far world flung.

They violently embraced in frenzy
The interests of their fancy:
Pygmalion thus became the lover
Of the Girl who called him father.

We twist as best we can
Our own dreams into proof.
Cool to what is real, each man
Is hot for the unreal untruth.

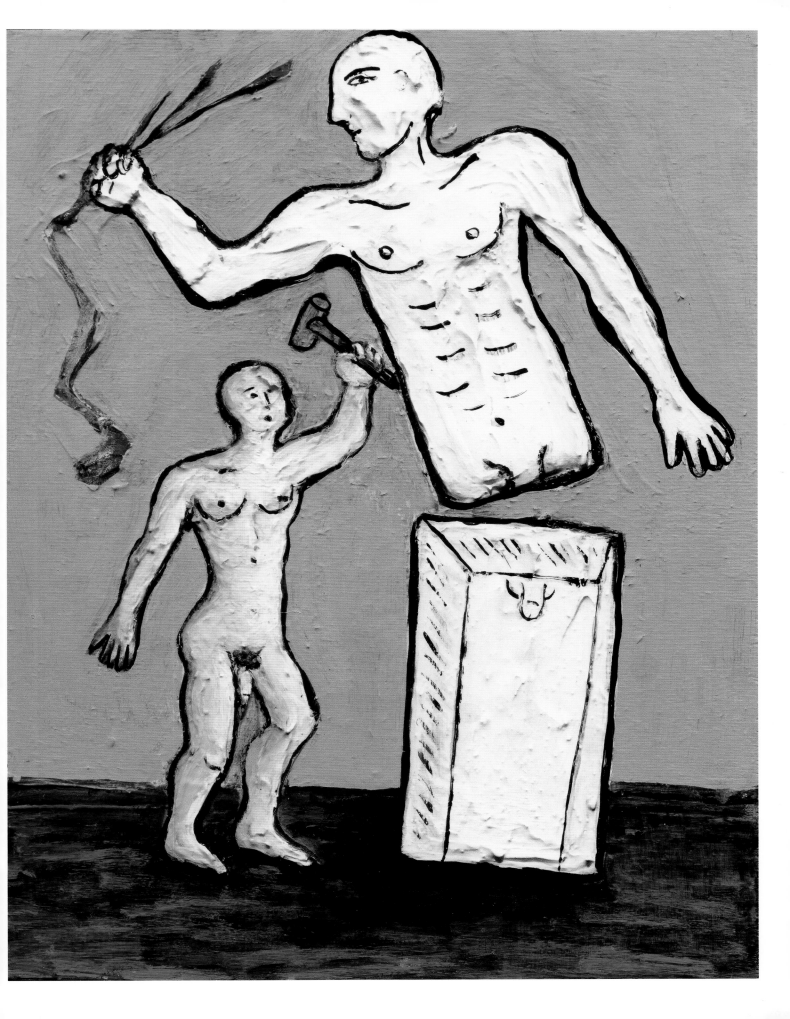

The Oyster and the Litigants

BOOK IX, FABLE 9

L'Huître et les Plaideurs

Laura Sharp Wilson, USA

One day two Pilgrims encountered an Oyster
On the sand, just arrived on a wave:
Their eyes gorged on it, pointing to it;
They argued as to who would open it.
One of them bent over to pick up the prey
While the other said: "It would be good to know
Which one of us would have the pleasure of enjoying it.
The first who noticed it will gobble it; the other will watch him."
"If that's how it is,"
Replied his companion, "thank God I have a good eye."
⠀⠀"Mine isn't bad either,"
Said the other, "and I swear I saw it first."
⠀⠀"You may have seen it, but I felt it."
⠀⠀During this exchange,
The lawyer, Perrin Dandin, arrives: they take him for the judge.
Perrin opens the Oyster ceremoniously, and tastes it,
⠀⠀While our two Gentlemen are watching.
The meal over, he says in a commanding voice:
"Here, the Court gives to each one of you a shell
Without charging you costs, and may you go in peace."

When you consider the costs of litigation these days,
Many families go to great expense,
While Perrin rakes the money in
And saves for the litigants nothing but a kick in the butt.

The Wolf and the Skinny Dog

BOOK IX, FABLE 10

Le Loup et le Chien maigre

Gérard Drouillet, France

In spite of protests,
 Carpillon ended up in the frying pan.
I realize that letting go an immature fish
 In the hopes of cashing in when
 It's grown is utter folly.
The Fisherman was right, but so was Carpillon:
One does one's best to defend one's life.
 Now, let me apply my reasoning
 To a Wolf and a Dog.
A certain Wolf, as foolish as the Fisherman was wise,
 Came upon a Dog at the city limits.
He was going to devour him, but the Dog pointed out
His manginess: "It would be a disgrace to your Majesty
 If you were to croak me in my present state.
 If you are patient, my master
 Is about to celebrate his only daughter's wedding,
And for that happy event, he'll no doubt fill me out."
 The Wolf falls for this and
After a few days comes back to realize that the Dog
 Is in the same shape.
 Through a grillwork gate the Dog said:
"My friend, if you can only wait, the Warden of the property
 And I will come out to meet you."
The Warden was in reality an Enormous Dog,
 Who knew how to dispatch Wolves without trouble.
The Wolf suspected a trap and started running away.
 He was nimble of foot
 But slow-witted;
He still had a lot to learn about what it means to be a Wolf.

The Candle

BOOK IX, FABLE 12

Le Cierge

Curt Labitzke, USA

It's to the abode of the gods
That the bees come first, they say,
 To Mount Hymettus, to gorge themselves
On the treasures that the Zephyr winds bring along.
When the ambrosia was removed from the palace
Of these Daughters of Heaven,
 Or to put it in French,
 When the beehives were left without honey,
Much wax was made, many a Candle was formed.
One Candle, seeing a brick hardened by fire
In a wink of time, wanted to do likewise;
And this new Empedocles, destined to the flames
 By his own pure folly,
Dashed in. It was bad reasoning;
The Candle knew nothing of philosophy.
Everything is different: remove from your mind
The idea that somebody has been created in the same way as you.
This Empedocles of wax melted in the heat:
He was no crazier than the other one.

The Monkey and the Cat

BOOK IX, FABLE 17

Le Singe et le Chat

Jim Hennessey, USA

Bertrand monkey and Raton the cat
Had the same master and were table pals.
They were a savory pair of fearless rascals.
If something in the house was out of whack,
The neighbors were beyond suspicion,
For Bertrand was a kleptomaniac
And Raton loved cheese: mice were not his mission.
One day, our two fine rogues
 Caught sight of chestnuts roasting in the fire.
To swipe them was an excellent affair;
Our tricksters saw a double profit there:
Firstly, their own advantage to inspire,
And secondly, of course, the harm to others.
Said Bertrand to Raton, "Brother's
 Got to pull a fast one now.
Come on, pluck out them nuts for me.
If God had given me the means
 Of taking chestnuts from a fire,
 We'd have 'em all, and I'm no liar."
No sooner said than done: for gingerly,
 With careful paw, Raton spreads the ashes,
Removes one chestnut, then another,
 Filching a third without delay
 As Bertrand gobbles up the evidence.
A servant comes. Farewell, my friends!
 Raton was not amused, they say,
Nor are those many sundry princes,
 Who, flattered by this kind of thing,
 Get burned and swindled in the Provinces
 For the sole profit of a king.

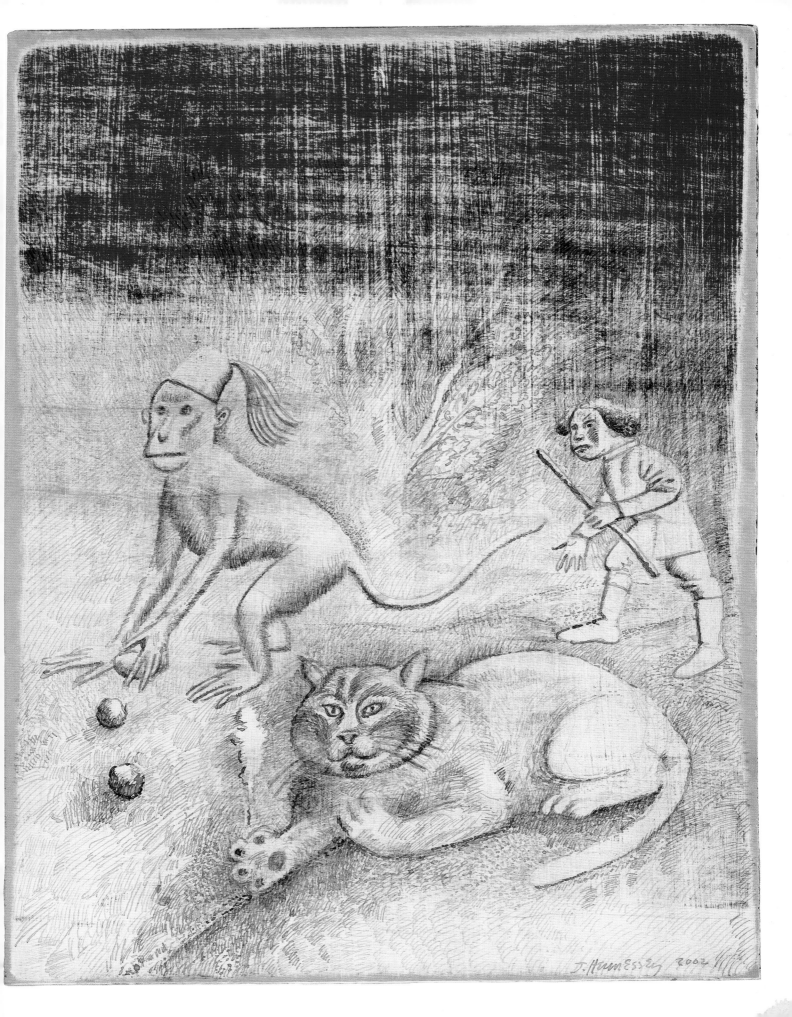

The Shepherd and His Flock

BOOK IX, FABLE 19

Le Berger et son Troupeau

Jo Smail, South Africa/USA

"What? I'll always miss each of the dumb ones
 That always the Wolf gobbles up!
I can't keep up with the count; they were more than a thousand.
Now my poor Robin sheep is snatched;
 Robin who always followed me around
 For a little piece of bread,
And who would have followed me to the ends of the earth.
Alas! A hundred feet away he could have heard my pipes:
 Ah, now poor Robin sheep!"
When Guillot the shepherd had finished this funeral oration,
 He harangued the flock,
From the chiefs, to the multitude, to the littlest lamb,
 Exhorting them to hold fast:
This, he declared, would keep the Wolves at bay.
They all gave their faithful word; they would stand together.
 "We want to stifle," they said, "this glutton
 Who stole Robin away from us."
 Everyone nodded.
 Guillot believed them and gave them a party.
 Nonetheless, before nightfall
 A difficulty arose.
A Wolf appeared; the flock fled.
It wasn't a wolf; it was but a shadow!
 Give instructions to bad soldiers,
 They will promise to be ferocious;
But the sign of the least danger, and good-bye courage:
The example you set and your words are to no avail.

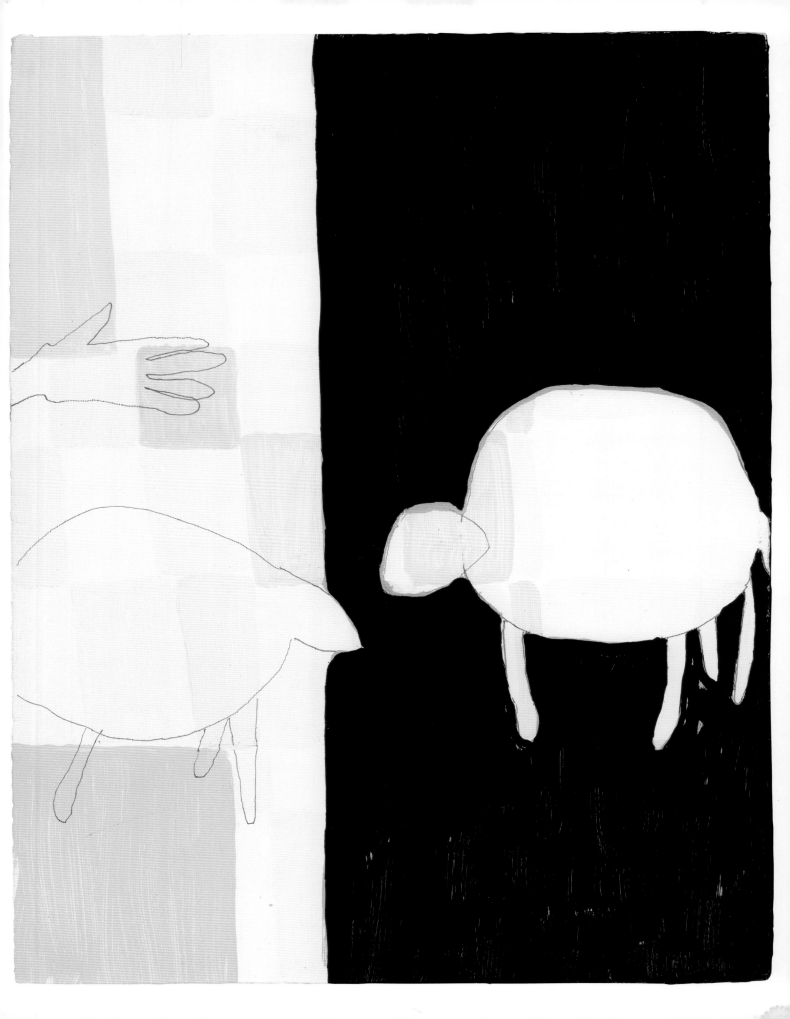

The Fish and the Cormorant

BOOK X, FABLE 3

Les Poissons et le Cormoran

Robert Jones, USA

Hardly a marsh in the neighborhood
Escaped the Cormorant's attention.
Living things and reservoirs paid his way:
His kitchen was well-stocked; but alas he got old
 And disabled, the poor animal,
 And his kitchen fell on hard times.
Cormorants look after themselves,
But our Cormorant in his old age couldn't see through the water,
 And, having no nets or fishing gear,
 He suffered from great hunger.
What was he to do? Need, the best doctor,
Came up with a plan. On the edge of a swamp
 The Cormorant saw a Crayfish.
"My friend," he said, "make haste.
 Deliver an urgent warning
 To your people: they are about to perish!
In eight days the master of these parts will fish you out."
The Crayfish rushes to report
The situation and causes great anxiety.
Fish, in a frenzy of worry, respond to the bird:
"Sir Cormorant, where did you get this information?
How do you know? Can you prove it? Are you sure about what
 you say?
Do you have a remedy? What should we do?"
"Change your home," he said. "How will we do it?"
"Don't worry. I'll carry you each individually,
 One after another, to my lair.
Only God and I know the way:
 There is no more secret hiding place,
A shelter that Nature shaped with her own hands,
Hidden away from treacherous humans. Save your republic!"
 They believed him. The aquatic hoard,
One after another, was carried onto a remote rock.
 The Cormorant, a good missionary,
 Having settled them in a clear pool,
 Not too deep, rather narrow,
Ate them at his leisure, this one one day, that one the next.
 He taught them at their expense
 That they shouldn't trust those who eat others.
They weren't that unlucky, since human need
Would have swallowed them anyway;
What difference does it make who eats you? A man, a wolf—
 It's all the same. A day earlier, a day later—
 It doesn't make much difference.

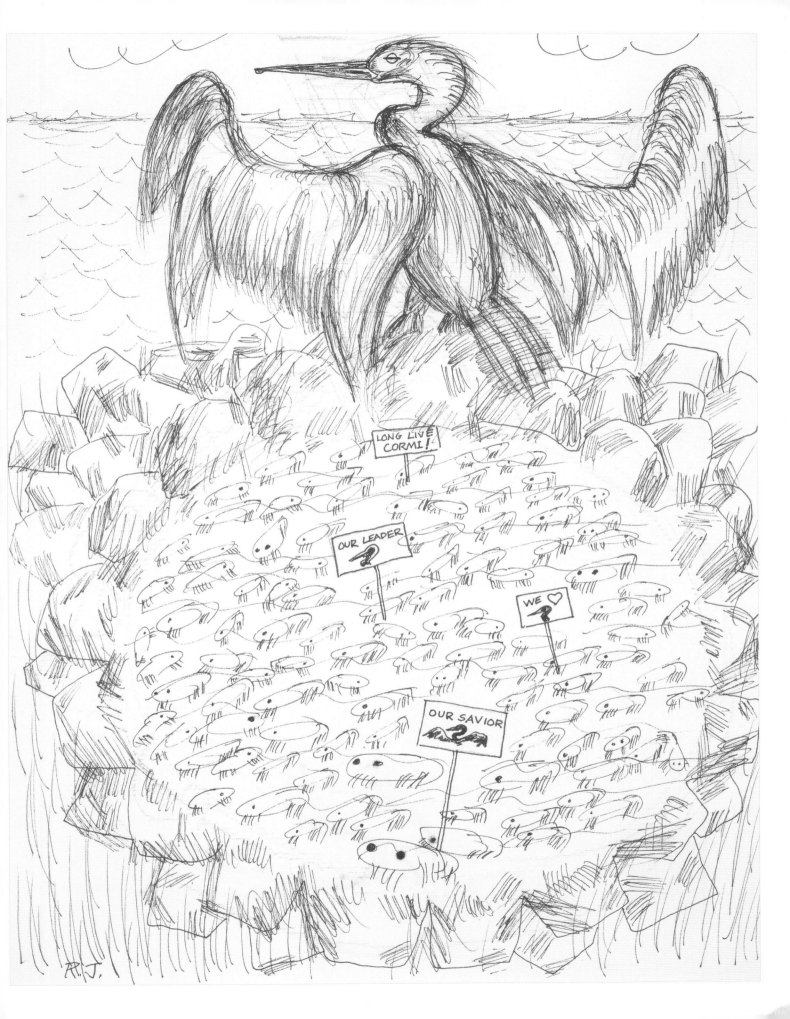

The Digger and His Godfather

BOOK X, FABLE 4

L'Enfouisseur et son Compère

Madeleine Marie Slavick, Hong Kong

A Pinch-penny had amassed so much
　　That he no longer knew where to stash his cash.
Avarice, companion and sister of ignorance,
　　Made it difficult for him
　　To find a safe place at home.
He didn't want one, and this is why:
"It would be a temptation; this pile of wealth must be hidden,
　　Because if I leave it in the house,
I myself might raid it, stealing from myself."
My friend, I feel sorry for you—you are making a mistake;
　　Let me teach you a lesson:
Wealth is only wealth if one is ready to give it up,
Otherwise it is an evil. You want to save it for your old age?
Then you wouldn't know what to do with it.
All the trouble to acquire it, all the trouble to keep it safe
Somehow devalues the very gold
　　That people think they can't live without.
　　To deal with this worry,
Our man thought he would turn to someone he could count on.
He preferred to bury it in the earth, and,
Asking his Godfather's help, the two of them did exactly that.
After a while, our man went back to check on his gold:
　　All he found was a hole.
Suspecting with good reason his Godfather,
He went straightaway to find the fellow.
"Let's get digging," he told him, "for I've some more money
　　To hide with the rest."
The Godfather rushed to rebury the stolen loot,
　　Expecting thus to filch the entire fortune.
But in this case, the other man proved to be wiser:
He took it all home and spent it at leisure, resolving
　　No longer to amass, just to enjoy.
And the poor thief, unable to find it, was crestfallen.

It's not bad to deceive the deceiver or to outdo a crook.

Omnipotence

Gold, you know exactly
where you are. You spread
a churched distance
you swell
with sweaty capitalism
you beg us
Why do we want to touch you?
Or do we want salvation?
Forget the silly trims and
accessories,
those daily ascensions
into the religion
of show and tell—
let the original
element, softer
warmer
resonate with earth
flesh
sweet
for in the evening, when the one
sun
and its show

collapses,
we too can fall
and the sigh
the sigh
if the golden arms that catch
us
are not malleable
with love
Somewhere, everywhere
in the sunflower fields
live moments
of joy. Nothing else
is needed. Quick,
before the late summer droop
begins
and gold gets sad
again. Quick, before we return
to gilded selves, protected
with years of the wrong
omniscience

The Fish and the Shepherd Who Played the Flute

BOOK X, FABLE 10

Les Poissons et le Berger
qui joue de la flûte

Bonnie Berkowitz, USA

Tircis the Shepherd, who for Annette alone
　　Sang as sweet as a flute in tune,
　　So sweet as to move even the dead,
　　Was singing one day along the water's edge,
　　In Zephyr's verdant domain.
　　Annette in the meantime fished with a line,
　　But no fish came her way.
　　The Shepherdess was wasting her time.
The Shepherd, whose songs charmed humans and beasts,
　　Believed (but believed wrongly),
That he could allure the fish.
This is what he sang: "Citizens of these waters,
Leave behind your Naiad in the deep grotto.
Come and see someone a thousand times more charming.
Be not afraid to come under the spell of the Beautiful One:
　　She is cruel only to me:
　　You will be dealt with gently,
　　It is not your life that is coveted:
A fish bowl brighter than crystal awaits you.
And even though this sort of "trap" could be fatal,
To die in the hands of Annette is an enviable death."
This eloquent speech fell on deaf ears.
His mellifluous words having gone with the wind,
He cast a long net and the fish were caught,
Lots of fish to lay at the feet of the Shepherdess.

O you sweet-tongued Preachers who preach to humans
　　(Rather than sheep),
Kings who think you can win over
The spirit of Man through sophistry,
　　This is not how things are done;
　　There's another way:
Using your nets gets you everything, through power-play.

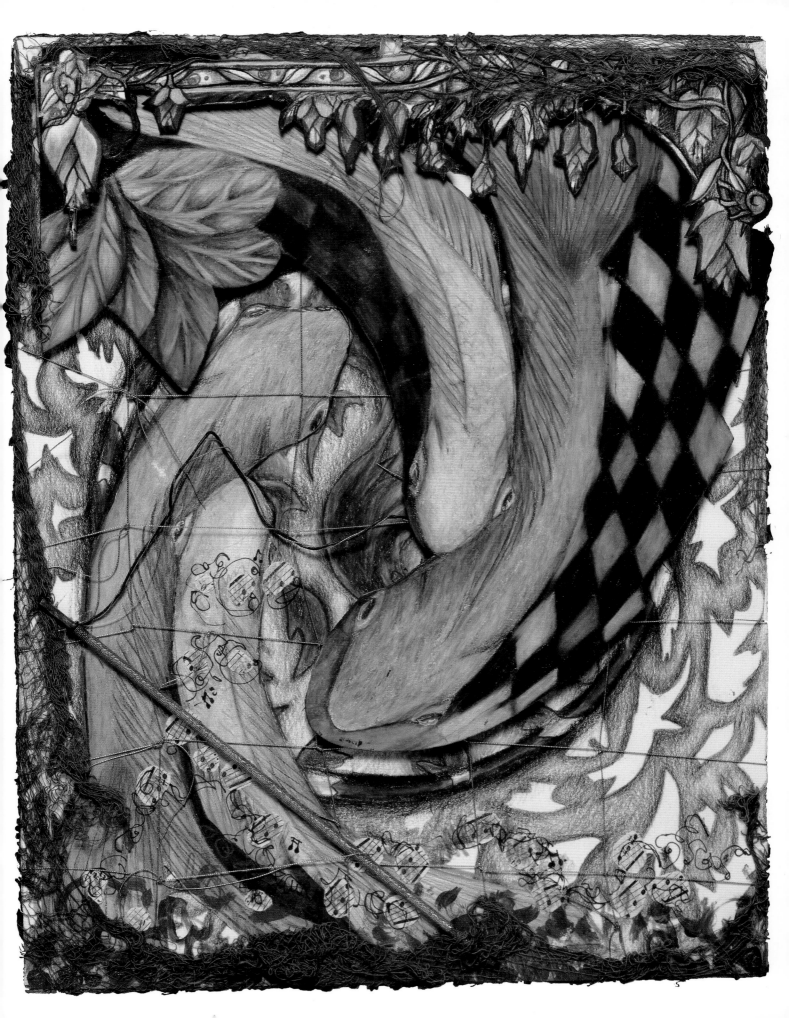

The Farmer, the Dog, and the Fox

BOOK XI, FABLE 3

Le Fermier, le Chien, et le Renard

Pam Keeley, USA

The Wolf and the Fox are strange neighbors:
I would never build a house next to them.
 The Fox watched at all times
The hens of a Farmer, but even though he was smart,
He could never manage to get to the chickens.
On the one hand, his hunger; on the other, the danger.
What an embarassment to our friend.
 "Alas!" said he. "This rascal
 Makes a fool of me with impunity?
 I go, I come, I work myself up,
I imagine a thousand tricks; this hick, quietly at home,
Makes money from his capons, his fowl. He doesn't
 go hungry.
As for me, an expert when I catch an old rooster,
 I'm all joy!
So why Sir Jupiter fated me to be a Fox? I swear by the powers
Of Olympus and Styx, he'll hear about it."
 Turning these vengeful thoughts about in his mind,
He chooses an evening strewn with poppies:
Everyone was in deep repose;
The Master of the house, the servants, even the dog,
Hens, chicks, capons, all slept. The Farmer,
 Having left the coop unlocked,
 Did something very stupid.
The thief, goes berserk in this place that he had his eye on,
Devastates it, filling this city with his murders.
 The signs of his cruelty
Were obvious at Dawn: One could see this spread
 Of bloody bodies, this carnage.
The Sun hid from this horror.
Once in a similar spectacle
 Apollo, angry at the proud Atrides,
Had strewn their camp with corpses: you could see
The bones of the Greeks, the work of a single night.
 Likewise around his tent,
 Impatient Ajax
Made a bloody debris of sheep and rams,

Believing that thus he was killing his rival Ulysses
 And the authors of this injustice
 Through whom he had won.
The Fox, another Ajax, fowl-killer,
Carried off what he could and scattered the rest.
All the Master could do was cry
Against his people, his dog. That's what people do.
—"Ah, cursed animal, good for nothing,
Why didn't you warn us when the slaughter started?"
—"You could have avoided all this, if you,
Master Farmer, who is most touched by this,
Had latched and secured the door before you retired.
You expect me, the Dog,
To lose my sleep?"
 This Dog spoke well.
 If only he had been a man;
 But since he was just a simple dog
 It was decided that he was useless,
 And they bloodied up the poor fellow.
You, then, whoever you are, head of a household
(And I have never envied you this honor),
 not waiting for the others
When you go to sleep is a mistake.
Go to bed last and make sure that the door is locked.
 You alone are responsible
 In things that matter.

The Dream of an Inhabitant of Mogol

BOOK XI, FABLE 4

Le Songe d'un Habitant du Mogol

Matt Freedman, USA

Once upon a time a certain Mogol dreamt of a Vizier
Who dwelt in Elysian fields, possessor of pleasures
Pure in value and infinite in duration.
The same dreamer saw in another country
 A Hermit surrounded by flames;
Even the unfortunate felt sorry for him.
The situation seemed strange and unusual;
In these two ghosts, Minos seemed to be confused.
The Mogol awoke, astonished and bemused.
Suspecting, however, a mystery surrounding this dream,
He had the affair explained to him.
The interpreter of dreams said: "Don't be surprised,
There is meaning to your dream, and, if in this matter,
I am not well versed,
It's a warning from the gods. During their mortal sojourn,
The Vizier sometime seeks solitude;
And the Hermit from time to time goes to court the Vizier."

If I might add a word to the interpreter's,
I would recommend the love of solitude:
It offers to its devotees good, unaffected things,
Pure things, gifts of Heaven that appear under our very feet.
O solitude, where I find a secret sweetness,
Corners of Nature that I have always loved, will I be able, ever,
To taste shade and cool air away from the noise of the world?
Who will bring me to a standstill under your shady shelters!
When will the Nine Sisters, away from the courts, take hold of me
Totally, and teach me the Heavens' movements, unknown to us,
The names and the properties of these errant planets
Which cause us to have different fates and different customs?
And if I've not been born to achieve great things,
At least the streams and the flowery riverbanks
Offer to me sweet themes that I paint in my verses!
The Parque with her golden threads will not weave my life;
I will not sleep in richly embroidered cloth.

But can we say that my time will lose its value,
Or be less profound, or have fewer delights?
I vow new sacrifices away from the world.
When the time comes to go to the dead,
I will have lived carefree and shall die without remorse.

Epilogue

BOOK XI

L'Épilogue

Simonetta Moro, Italy

Thus my Muse, cresting on a limpid wave,
Interpreted in godlike language
The utterances of so many creatures,
So many different tribes
Who attempt to fathom Nature's idiom.
These beings I used as Actors in my work;
Because in this Universe no living things
Lack a proper language of their own:
All are even more eloquent in their exchanges
Than they seem to be in my Poetry.
 And though there are some who think
That I am not close to nature,
And that my work is not a good model,
 At least I pioneered something.
 Others can give the perfect touch.
Favorites of the Nine Sisters can finish the job:
Give us the lessons that I have not given to this art.
But you are too busy.
Even as my innocent Muse does her best,
King Louis is subjugating Europe,
 And with a strong hand, he guides
 The most notable projects to a conclusion
 Better than any Predecessor.
Favorites of the Nine Sisters, these are some topics
To take up and deal with in time and with inspiration.

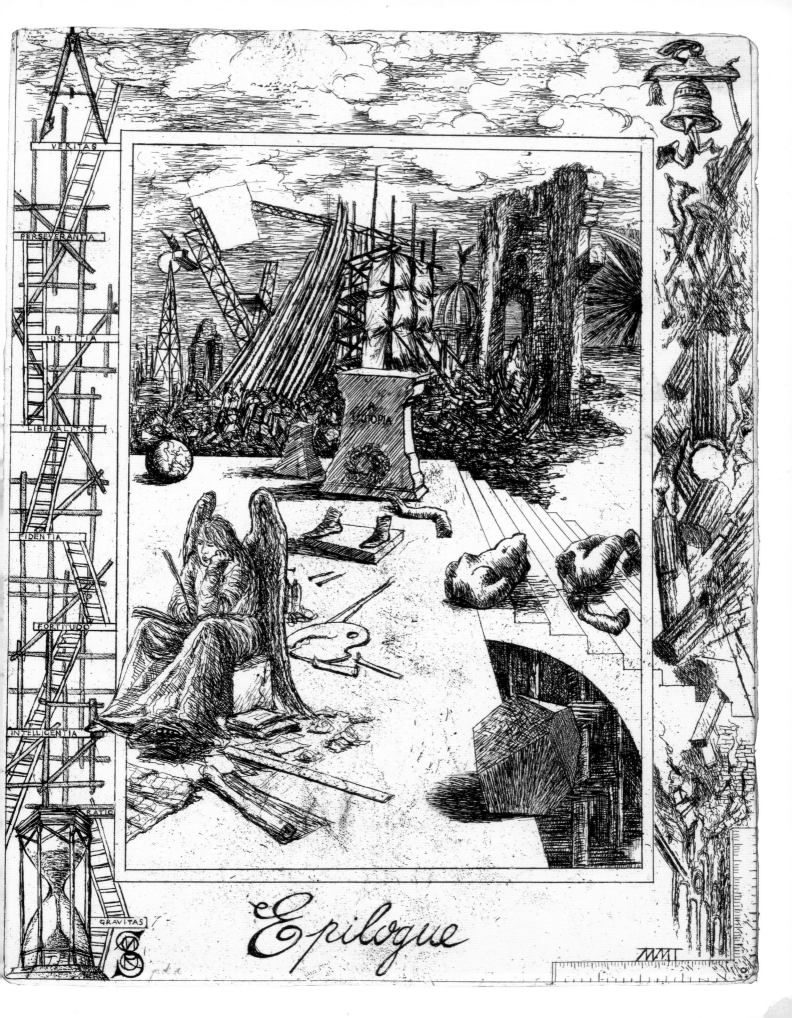

VERITAS

PERSEVERANTIA

IUSTITIA

LIBERALITAS

FIDENTIA

FORTITUDO

INTELLIGENTIA

RATIO

GRAVITAS

UTOPIA

Epilogue

The Cat and the Two Sparrows

—Dedicated to the Duke of Burgundy

BOOK XII, FABLE 2

Le Chat et les Deux Moineaux

Shelley F. Marlow, USA

A Cat and a very young Sparrow
Had been neighbors since a tender age.
The Cage and the Basket were in the same lodging.
The Bird often got on the Cat's nerves:
The one fussed with its beak, the other with its paws.
The Cat, however, spared his friend.
 He chided it half-heartedly
 And was scrupulous about his authority;
 The Sparrow, less circumspect,
 Would pick on the Cat.
 Discreetly wise,
 Master Cat overlooked these little games.
Between friends one should never allow
 Serious disagreements.
Since they had known each other since childhood,
Their games never turned rough.
 When a neighboring Sparrow
Came to visit the impetuous Bird and the wise Cat,
The two Birds quarreled
 And the Cat had to take sides.
"This outsider," said the Cat, "has insulted my friend;
The neighboring Sparrow comes to pick a fight
 With mine—I won't allow it."
And joining the fight, he devours the foreigner.
"Hm," says the Cat. "Sparrows taste delicious."
And this thought led to the devouring of the other as well.
What moral can I infer from all of this?
Without a moral, Fables are incomplete.
I think I see the point vaguely;
Your Highness, you may find the contestants unruly;
You may think that these are games; my Muse does not.
But then, the Muses are not as smart as you.

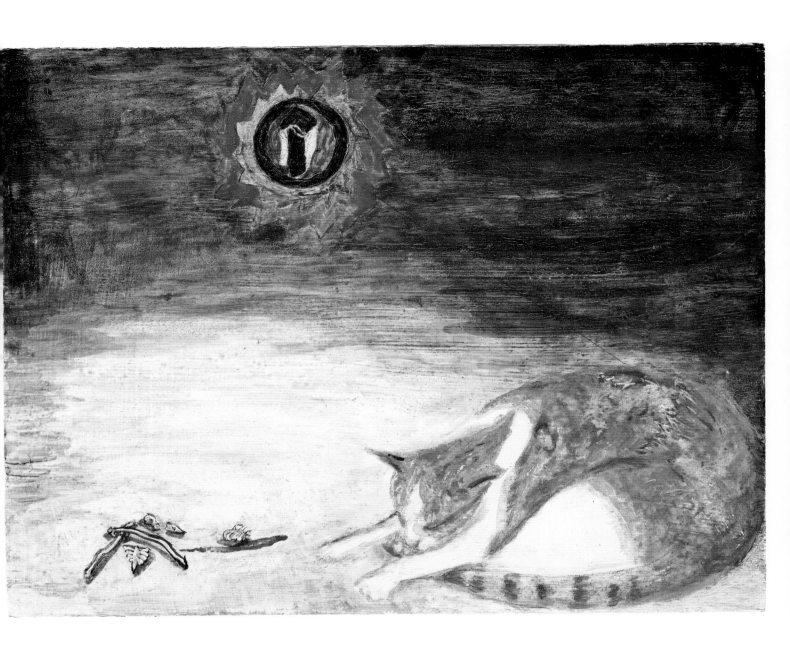

The Two Goats

BOOK XII, FABLE 4

Les deux Chèvres

Paul Berger, USA

As soon as the Goats had flirted
With a certain sense of freedom,
They went in search of their fortune; they traveled
Well past the pasture,
Places that humans didn't frequent,
Places without a road or path,
Rocky outcroppings on a precipice,
That is where these ladies trotted to seek their whim;
Nothing can stop this animal. It knows how to climb.
The Two Goats were thus emancipated,
Each on its own white hoofs
Left the prairie below, each on its own way.
They met again at a stream, with a plank of wood as a bridge,
Too narrow for Nannies to pass head on.
Besides, the rapid water and its depth
Should have scared off these Amazons.
Against all dangers, one of them
Put a hoof on the plank, the other did likewise.
It was like Louis the Great,
Watching Philip the Fourth advance
Toward the island of their meeting.
Nose to nose our adventuresses,
Mightily proud both,
Advanced to the middle of the bridge, neither wanting
To yield to the other. Each had glory
Which counts in their race (according to History).
The one peerless Goat, like the one
Polyphemus offered Galatea:
The other, Almathea,
Who nursed Zeus.
Since neither would back off,
Both fell into the water.
This accident is not unusual
On the road to Fortune.

The Fox, the Wolf, and the Horse

BOOK XII, FABLE 17

Le Renard, le Loup, et le Cheval

Gian Luigi Giovanola, Italy

A Fox, wily in spite of his youth,
Saw the first Horse of his life.
He turned to an equally young Wolf and said:
 "Come see an animal in our pasture;
He is big and beautiful; he really amazed me."
"Is he stronger than we?" said the Wolf, laughing.
 "Describe him please."
"If I were a Painter, or even a Student,"
Continued the Fox, "I would add to the pleasure
 Of your first sight.
But let's go: What do we know, he is perhaps prey
 Sent to us by our good Fortune."
So they did go: and the aloof Horse, who had been grazing,
 Almost took off.
"Lord," said the Fox, "your humble servants
Would be delighted to know your name."
The Horse, who was not dumb,
Answered: "Come read my name, Sirs.
The Bootmaker inscribed it on my shoe."
The Fox apologized for his ignorance.
"My parents," he continued, "did not give me an education.
They are poor and live in a hovel. But the Wolf's
Parents are important people and taught him how to read."
 The Wolf, flattered by these words,
 Approached, but his ego cost him four teeth:
The Horse planted a hoof that left the Wolf
 Bleeding on the ground, demolished.
"Brother," said the Fox, "this proves what some
 Learned people told me:
This animal inscribed on your jaw the following:
Let the wise person be wary of all strangers."

The Elephant and Jupiter's Monkey

BOOK XII, FABLE 21

L' Éléphant et le Singe de Jupiter

Jenny Lynn McNutt, USA

Once upon a time the Elephant and the Rhinoceros
Were arguing about rights and privileges of domain.
They agreed to settle their quarrel by combat, face to face.
They set a date, when out of the blue, someone came to tell them
 That Jupiter's Monkey,
Carrying an olive branch, had appeared in space.
The Monkey's name was Gille, according to the story.
 The Elephant, of course, believed
 That an Ambassador
 Was being sent to find his Grandeur,
 And he took pride in this glorious moment.
He considered, while waiting for Master Gille,
 Who was taking his time in coming,
 How to present his credentials.
Finally, Master Gille appeared, somewhat casually,
 And offered his greetings.
The Elephant waited and waited to hear details of the mission;
 But not a word came out of the Monkey.
The importance that the gods assigned to this quarrel
 Was obviously not great.
Disappointed, the Elephant realized that
The Olympians did not distinguish between Elephants and Flies.
So he took it upon himself to broach the subject:
"My cousin Jupiter," he said, "will soon watch
From his exalted throne, along with his entire court,
 A beautiful contest."
"What contest?" asked the Monkey, with a darkened brow.
"What! Don't you know," continued the Elephant,
"That the Rhinoceros is disputing the extent of my domain?
That the Elephant race is at war with the Rhinoceros species?
Surely you know this part of the world, and its fame."
"I'm very pleased to be informed of these things,"
Responded Master Gille: "In our vast empire
We hardly take up this sort of conflict."
 The Elephant, embarrassed and ashamed,
Says: "What are you doing among us then?"
—"I came to oversee the distribution of food
Among a tribe of Ants. We take care of all
Living things: As for your affair,
It still hasn't reached the ears of the Divine Council.
At any rate, large or small, all are the same in their eyes."

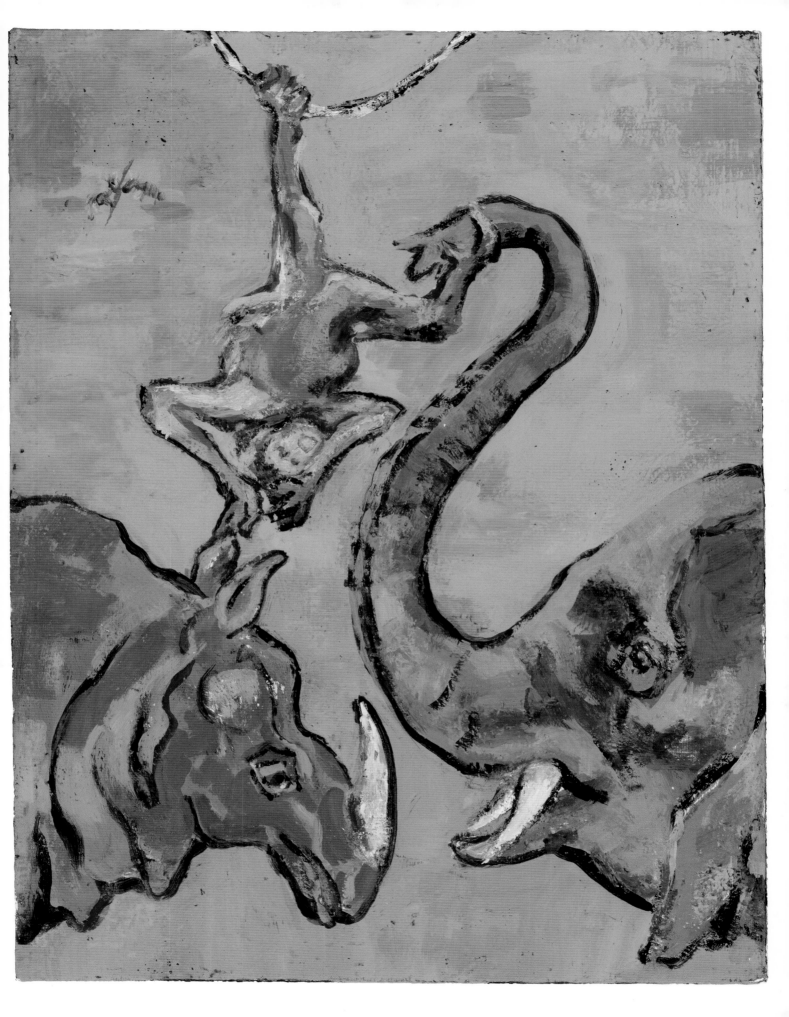

Philémon and Baucis

A subject drawn from Ovid's Metamorphoses

——Dedicated to the Duke of Vendôme

BOOK XII, FABLE 25

Philémon et Baucis

Susanna Coffey, USA

Neither gold nor glory brings us happiness.
Those two Divinities deliver doubtful blessings—
Gnawing worries forever beset one's refuge,
As surely as Vultures gnawed at Prometheus,
Chained on his morose peak.
A humble house is exempt from such a sad tribute.
The Wise Man lives there in peace and dismisses the rest.
Happy with what he has, walking in the woods,
He knows himself better off than the King's favorites.
He can read on the worried foreheads of those
Who are surrounded by vain luxury,
That Fortune sells whatever we think she gives freely.

Philémon and Baucis are a case in this point.
Both saw their Hut transformed into a Temple.
Love and Marriage fulfilled their desire,
Uniting their hearts since the days of their sweetest Spring.
Clothon took pleasure in weaving their lot.
They learned to cultivate their land themselves,
Working together for two times twenty summers,
Happy not to owe to anyone the pleasure of their mutual caring.
But everything ages. Wrinkles appeared on their brows.
Friendship attenuated their ardour without, however,
Destroying it,
And Love they even shared.

But they lived in a land where the people had the habit
Of mocking life's harshness.
Jupiter decided to abolish these despicable people;
So he journeyed with his son, the God of Eloquence,
Pretending to be Pilgrims who wanted to visit this place.
Out of a thousand homes, not a single one
Opened its door to the gods.
Ready to give up on this fruitless journey,
They spotted a small hut, out of the way.
Mercury knocked; someone opened.
Philémon came out to greet the gods and said,

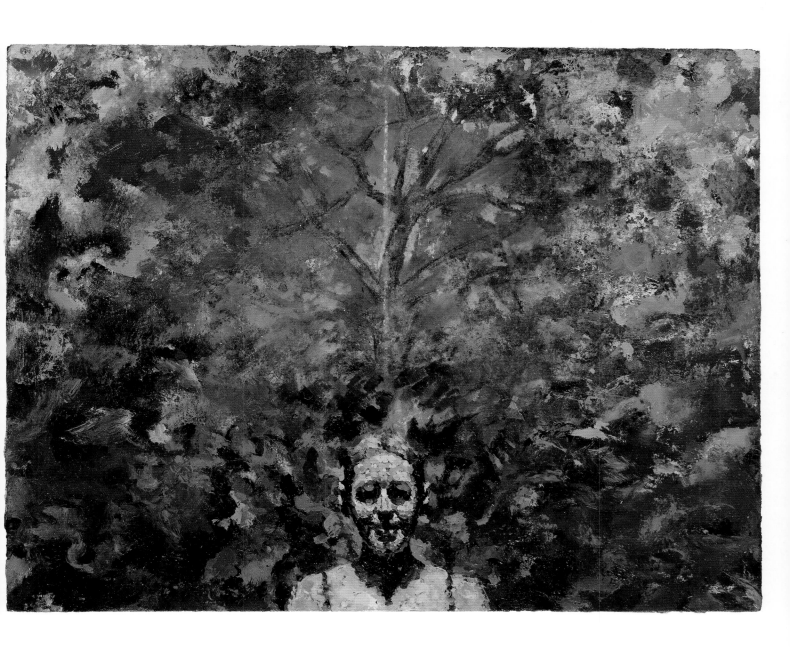

"You both look exhausted from a long journey,
Please come in and rest. Feel free to use what we have.
It is the gods who helped us with whatever you see.
Please greet these household gods.
Never was life easier
Than when Jupiter was represented in wood.
Since they turned him into gold, he seems to be
Deaf to our pleas.
Baucis, hurry and warm the water,
So that our guests can be treated properly."
Cinders and logs in the fireplace,
When Baucis breathed on them, came to life.
With warm water the feet of the Voyagers were washed.
Philémon asked them to forgive the time
These preparations were taking,
And to kill time he talked to the gods, not about
Fortune or the pomp and grandeur of Kings,
But about the fields and the thickets and the woods
And how sweet nature is.
In the meanwhile, Baucis prepared a supper
And served a peasant meal.
She covered with old carpets a couple of stools
For the special occasion, and she spread as well a flowered
Tablecloth for the milk, the fruit, and the cereals—
The gifts of Ceres.
The divine Travelers wet their throats
With ordinary wine.
And the more they drank, the more the pitcher replenished itself.
Philémon was quick to detect a miracle,
Baucis also. They both knelt
And suddenly saw Jupiter with his dark lashes
That make the World tremble on its axis.
"Good lord," said Philémon,"forgive us.
How are humans expected to receive such a guest?
This food, we must admit, is not the finest."
Baucis went out to the garden, to amend this misunderstanding.
There she saw a tame partridge
That she had looked after since she was very young.
She wanted to turn the bird into a meal, but she couldn't catch it
Because the bird found asylum among the legs of the gods.
Already it was getting dark in the valley
And the gods were ready to leave.
Said Jupiter, "Come, I want to punish the sins of this land.

Old folks, follow us! Mercury, go and get the winds.
O you hard people, who do not open your doors to us
Or your hearts!"
The Couple were following with difficulty, but they
Managed to climb the mountain
And found themselves above a hundred clouds.
Messengers of the gods carried away in a windstorm
Trees, houses, vegetable gardens, animals, inhabitants.
Everything in that land disappeared in an hour.
The old ones felt sorry about this severity.
Baucis shed some secret tears.
Meanwhile, the humble Hut became a Temple,
And its walls, marble.
The building reached the heavens; the thatched roof
Turned to gold; all was shining in this enclave.
Our couple, amazed, thought themselves on Olympus.
"You take care of your humblest creatures.
Are our hearts and hands pure enough," they asked,
"To take part in these divine honors
And, O Priests, to offer you the vows of pilgrims?"
Jupiter listened to their innocent prayer.
"Alas," said Philémon. "If your powerful hand
Granted your favor to two mortals,
Together we'll die serving your altars.
Clothon would with one blow perform this double sacrifice.
I won't weep for her, whose tears will
No longer be shed in this place."
Jupiter liked this promise, too.
But dare I tell you about an incredible thing?
One day when we were seated on the sacred terrace,
Our couple recounted this tale to some delighted pilgrims,
And the group around them was listening hard.
Philémon said to them, "This place is full of wonder,
And it wasn't always a Temple to the Immortals.
There was a town, an enemy of the altars,
And barbarian people, hard people, impious people—
Victims all of divine wrath.
Only the two of us were left among this sad debris.
You'll find the rest of the story on our clothing
Painted by Jupiter." As he was telling this tale, Philémon
Was casting a glance at Baucis.
She was becoming a tree and was extending her arms.
He wanted to touch her, but he could not.

He wanted to talk to her, but bark had sealed her mouth,
And she, meanwhile, saw her husband sprouting leaves:
Baucis became the Linden, Philémon, the Oak.
Let us celebrate this metamorphosis.
With the aid of Clio, Homer, and Apollo,
I have brought this story
To the shade of the trees that live along these shores.
I humbly offer my verses,
As we listen to the whisper among the leaves, the intimate secrets
They confide in one another, in their embrace.

The Matron of Ephesus

BOOK XII, FABLE 26

La Matrone d'Éphèse

Susanne Slavick, USA

If there is one common tale that is overworked,
It's the one that now through verse I shape at will.
 "So, you ask, why choose it?
What makes you get involved in this enterprise?
Don't we have enough comments on it?
 How graceful can you make this Matron
 At the expense of that by Petronius?
How can you make her fresher in our minds?"
Without answering my critics—for that is an infinite task—
Let's see if I can rejuvenate her through my verses.

 Once upon a time in Ephesus
Lived a lady without peer in wisdom or virtue.
 And who was by common consent
A paragon of conjugal love.
Everywhere people spoke of her chastity—
 And looked upon her as a rarity:
She was the pride of her sex, the joy of her nation!
Each mother to her daughter-in-law gave her as example;
Each husband urged the same to his own dear wife.
(From her came the Virtuous,
 Ancient and famous family.)
 Her husband loved her with mad love.
 And he died. To detail how
 Would be frivolous;
 He died, and his Will
Was full of legacies that were consoling,
If such things could replace a husband
 Who was so dear and beloved.
Many a widow, however distraught,
While not ceasing to care for the dead,
Would count his wealth while weeping.
This one, by her cries, alarmed them all;
Her regrets could pierce every heart,
Even though one knows that in these misfortunes,
Whatever the despair the soul suffers,
The plaint is often louder than the pain:

There is much ostentation among the tears.
Everyone found it their duty to tell her that such tears
 Could commit the sin of excess:
And thus did they compound her grief,
Till in the end she wished no longer to live,
 Now that her husband was gone.
She descended into his tomb, fully determined
To follow him into the underworld.
Thus you see where excessive love can lead
Almost to madness.
A slave through pity followed her,
Ready to die in her company.
By ready, I mean, in a word,
 With rash courage.
The slave and the Lady had been children together,
They loved each other, and great affection
Increased with age in the heart of the two women.
In the whole world, one seldom finds such a model
 Of sisterly devotion.
As the slave had more sense than the Lady,
She tried in vain to restore our Lady's way of life,
Who was trying her best to follow the departed one
 Into the dark abyss,
She wanted to be with the corpse,
 Her only sustenance.
A day or two passed with sighs as her only food,
Along with murmurs against the gods.
 In short, her pain and sorrow
 Left nothing unsaid.
Another body lay there, not far away,
 Under a gallows,
Left there as an example to thieves.
 A well-paid soldier
 Was guarding it with vigilance,
 For an Ordonnance decreed
That if other thieves, a parent, a friend
Took it, the nonchalant, sleeping soldier
 Would have to take its place.
 (It was too severe;
 But meant for the public good . . .)
During the night he saw in the vents of the tomb
Something shining brightly, a new spectacle.
Curious, he ran, hearing the Lady from afar.

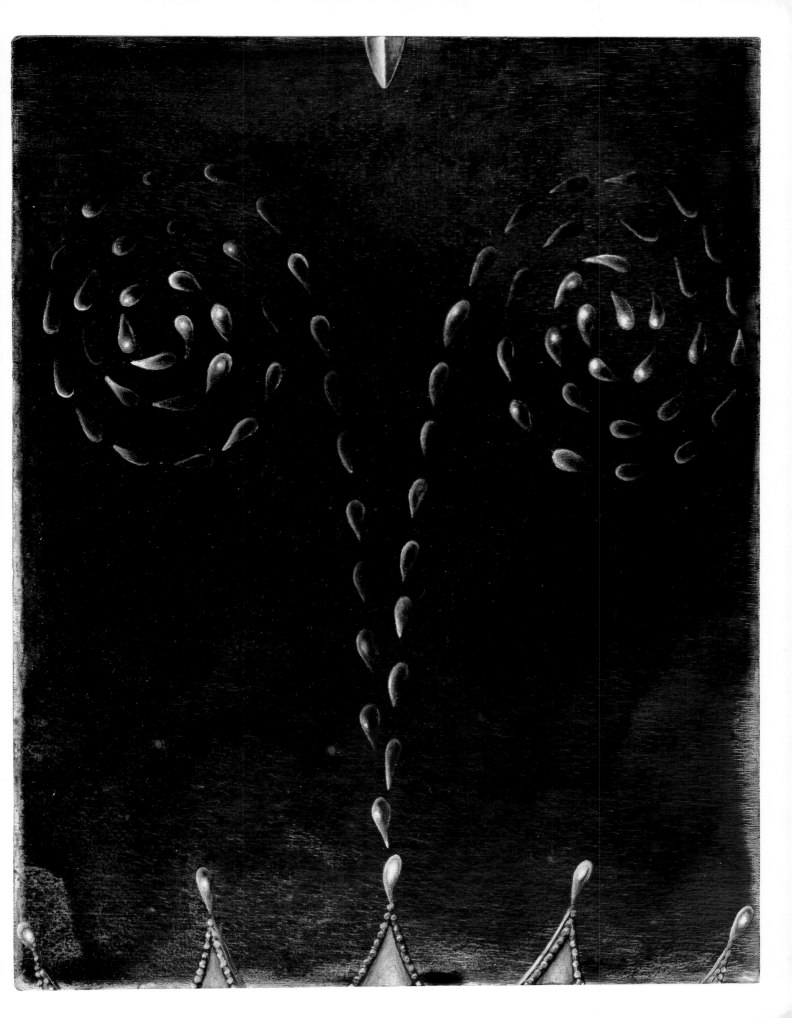

Such a commotion, where was it coming from?
He enters. Surprised, he asks this woman:
 Why the cries? why the tears?
 Why this sad music?
 Why this dark and melancholy place?
Caught up in her tears she could hardly answer him
As to why she was burying herself alive.
"We swore," said the servant, "to die through hunger and sorrow."
And even though the soldier hadn't the gift of words,
He explained to them what life was all about.
This time the Lady listened;
 And already her other
 Obsession subsided.
Time had had its course. "If the oath,"
Said the soldier, "forbids you to eat,
 Just watch me eat.
You can still go ahead and die." Such a speech
 Did not displease the two women:
 And thus he obtained from them
Permission to bring his supper;
And he did; so that the slave's heart was tempted
To renounce the cruel decision
To keep the corpse company.
"Lady," she said, "I had a thought.
Your husband doesn't care if you cease to live.
Do you think that he would have followed you
 Into death?
No, Madame, he would want to fulfill his career.
Ours could be long if we wish it.
Do we need at twenty to bury ourselves?
We have houses to enjoy.
One dies soon enough; what's the hurry?
As for me, I would rather die when I'm wrinkled.
Why take your beauty to the dead?
What good is it to be seen there?
And when I see the beauty of your face,
I say, alas, it's a pity for both of us."
At this flattering discourse, the Lady woke up.
The god who causes us to fall in love, took
Two arrows from his sheath and shot
The Soldier and the Lady each.
The Soldier was smitten with tears and tenderness.
Everything worked. The beautiful one was doubly

Pretty in her tears.
He gave her food and showed himself worthier
Than her dead husband.
And gradually—I don't find this strange—
She listened to a suitor soon to be her husband;
All of this under the nose of the dear departed one.
During this "marriage," a thief happened by and removed
The treasure that the Soldier was supposed
To be guarding.
He heard a noise and ran out;
But in vain. The deed was done!
He returned to the grave, embarrassed,
Not knowing what to do.
The slave said,
"Have you lost the body you were guarding?
The law will not forgive you. If it's all right with Madame,
 Let us replace him with our corpse.
 No one will be the wiser."
The Lady agreed. Oh, flighty women!
Woman is woman; some are beautiful, others are not.
 If only they were faithful,
 They would be more attractive.

Prudish ones, do not cluck.
If your intention is to resist temptation,
Our intentions are good too, but carrying them out
Is the proof of the pudding. Witness this Matron.
With due respect to the good Petronius,
It wasn't all that marvelous a thing,
His proposed example to posterity.
This widow was wrong to make such a fuss
Over her ill-conceived plan to die;
 Because to put to rest on the gallows
 The body of her beloved husband,
Was perhaps no big deal;
And through this, the other was saved.
 All things considered,
Better to have an officer on his feet,
Than an Emperor in the ground.

ACKNOWLEDGMENTS

This publication would not have been possible without the indispensable support of all kinds from friends and without Donald Ellegood's unwavering belief in its merit. Our gratitude is extended to Jane and David Davis, Anne Dedet, Elisabeth Dimitriades, William and Ruth Gerberding, Tracey Hinkle and Richard Lorenzen, Anna Kartsonis, Boris and Narelle Mishel, Joanne Snow-Smith and Robert Willstadter, Katina Van Sinderen, William Wickett and Cecilia Cooney Wickett, and James D. and Bea Williams.

Also we thank our many friends whose generous support has helped make this publication possible:

Arellano-Christofides Architects

The Boeing Company

Tom and Elaine Bosworth

Alfred and Arlene Carsten

Emmanuel Christofides

Vasiliki Dwyer

Donald Isle Foster

Thomas G. Gambling
and Mary Louise Hart

Kevin Grayum and Suzanne,
Michael, and David
Eklund-Grayum

Ernest and Elaine Henley

Leonard D. Hudson

Davor and Breda Kapetanic

Joseph T. and Lisa O. Krause

Elaine and R. Joseph Monsen

Daniel and Arundhati Neuman

Robert Phelan

George W. Poe

Ronnie L. Sharfman
and Joseph Youngerman

John B. Simpson

Eileen Soldwedel

Carol Thomas
and Richard Johnson

Rick and Nancy Thompson

Peter Van Oppen

In addition we want to thank the following people at each of the venues for the Fables of La Fontaine exhibitions:

The Center for Art and Culture of the Maryland Institute College of Art at the Institute for American Universities, Aix-en-Provence, France: David Wilsford, Grace Anderson, Yamina Boudellal, Xavier Henry, Anne Jourlait, Kristin Ouerfelli, and Céline Panico

Temple University Rome, Italy: Shara Wasserman, Teresa Morelli, and Kim Strommen

The Jacob Lawrence Gallery, University of Washington, Seattle, USA: Christopher Ozubko, Lynn Bazarnic, Kris Jones, Mark Rector, and Philip Schwab

The Meyerhoff Gallery, Maryland Institute College of Art, Baltimore, USA: Ray Allen, Victoria Hecht, Fred Lazarus, and Gerald Ross

Once again, Koren Christofides would like to extend her gratitude to all the artists in the Fables Project and to her fellow curators, Ken Tisa and Robyn Chadwick.

The intellectual exchanges antecedent to the composition of lectures on La Fontaine and his century, given at various exhibition venues in compressed form, became the Introduction to this volume. In it, Constantine Christofides takes delight in recalling and thus summoning up a generation of dix-septiémistes on both sides of the Atlantic: the late Frank Warnke and Wolfgang Leiner; Jules Brody, above all; Daniel Jourlait; and Douglas Collins, who has always been there with insight and erudition.

This work would not have been possible without Don Ellegood's conviction that it was a worthwhile, exciting, and original project. His successor as Press director, Pat Soden, took up the cause. Audrey Meyer, the Press's art director and supreme book designer, gave it loving attention. Editor Gretchen Van Meter approached the task of editing our translations from the French with elegance and authority. She gave clarity to a number of passages in both the prose and poetic renderings, such as only a student of Marianne Moore could have done. Immense thanks go to her and to Managing Editor Marilyn Trueblood. Denise Clark and Hady De Jong efficiently handled logistical information that related to our sixty-five artists, and the complex issues of publication subsidy found a rare advocate in Nina McGuinness, herself a distant descendant of our Poet.

Constantine Christofides, Koren Christofides, and Christopher Carsten.
Photo by Nouma Bordj.